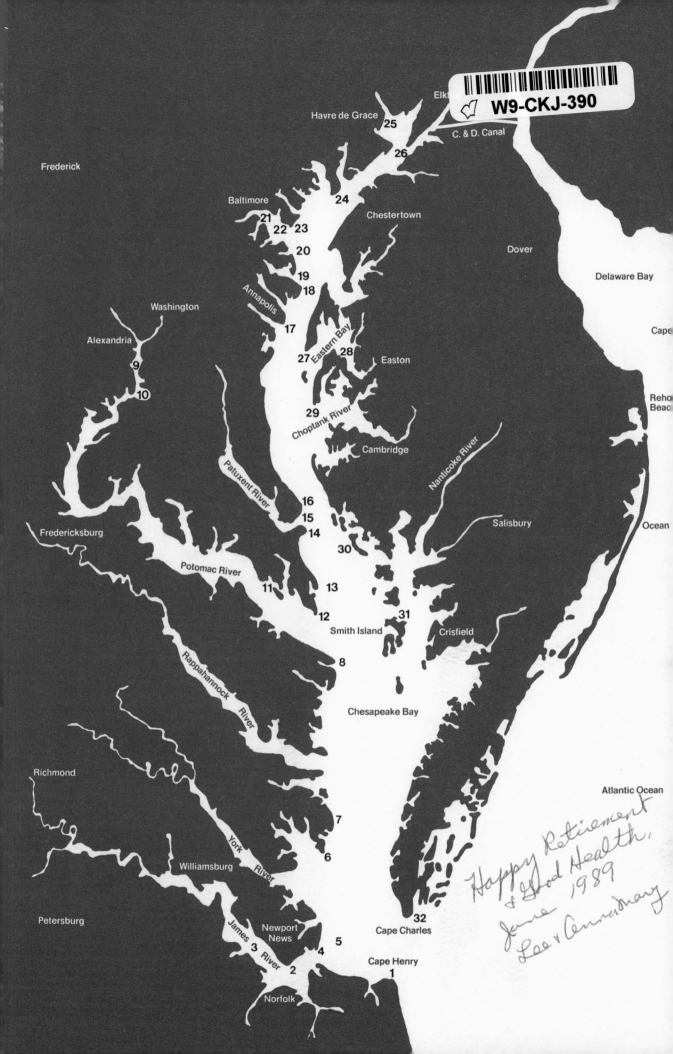

The
Lighthouses
of the
Chesapeake

The Johns Hopkins University Press
Baltimore and London

The
Lighthouses
of the
Chesapeake

Robert de Gast

Originally published, 1973
Second printing, 1976
Third printing, 1985

The Johns Hopkins University Press
701 West 40th Street
Baltimore, Maryland 21211
The Johns Hopkins Press Ltd., London

The paper used in this publication meets the minimum requirements of American National Standard for Information Sciences — Permanence of Paper for Printed Library Materials, ANSI Z39.48–1984.

Library of Congress Cataloging in Publication Data

de Gast, Robert, 1936–
 The lighthouses of the Chesapeake.

 Bibliography: p. 172
 1. Lighthouses—Chesapeake Bay—Pictorial works. 2. Photography—Marines. I. Title.
VK1024.C46D4 387.1 73–8216
ISBN 0–8018–1548–7

Contents

What is a "proper" lighthouse? The U.S. Coast Guard, since 1939 charged with the responsibility for maintaining aids to navigation, does not differentiate between lights and lighthouses. According to one eighteenth-century definition a lighthouse is "a machine ministerial to the more commodious or conspicuous exhibition of a light." But that is too broad, for it would today encompass any kind of lighted buoy and any kind of light. For example, for many years there was a light at Dutch Gap, on the James River near Richmond, the site of the first canal dug in the United States. A house for the keeper was also provided, but the light was 200 yards from the house and consisted of nothing more than a tiny lantern suspended from a 10-foot tripod made from tree limbs. A small ladder assisted the keeper to the top to light or extinguish the oil lamp. Because of its protected location, an enclosed structure was simply not needed.

To me, this is not a lighthouse. In 1755 Samuel Johnson defined a lighthouse as "a high building at the top of which lights are hung to guide ships at sea." I agree with Dr. Johnson: a building, an enclosed structure, seems more precise than a tower or machine. But one more qualification has to be met: there had to be a lighthouse keeper, someone living in the lighthouse or in a separate dwelling nearby.

All the lighthouses described in this book meet these two qualifications. The total number, 74, refers only to various locations where they were built, for several places had more than one lighthouse; Smith Point and Sharps Island each had three, for example. Many were destroyed by fire or drifting ice or the vagaries of water and wind. The range lights near the entrance to Baltimore Harbor are thus counted as one, for they function as a unit, although the buildings are described separately.

The book is divided into three sections: an Introduction which gives a short history of lighthouses, with special emphasis on their function in the Chesapeake; 32 illustrated essays on the lighthouses still standing; and short descriptions of the 42 lights that have been destroyed. The

Chesapeake Bay and its tributaries encompass all the waters inshore of a line drawn from Cape Henry to Cape Charles. The sequence used here takes the form of an imaginary journey by boat around the Bay. We begin at Cape Henry, the oldest lighthouse on the Chesapeake, proceed up the Western Shore, poking up all its rivers, to Havre de Grace, then turn southwards along the Eastern Shore to Cape Charles. The locations of the lighthouses are shown on reduced Coast and Geodetic Survey charts; one inch equals one nautical mile. Used with the maps of the Bay which appear on the endpapers, these charts will help the reader locate all the lighthouses mentioned, whether still standing or not.

In each case the name of the lighthouse given is the one which was in vogue when it was last occupied. Janes Island light, for example, is now called James Island light; Cape Charles light was for years called Smith Island light, which is all the more confusing because another Smith Island was the site of Fog Point lighthouse. Also, the names of the lighthouses may have been given to new, automated structures after they were dismantled. Whenever possible I have tried to show the lighthouses as they looked in the first years of their existence, uncluttered by modern backgrounds. The photographic view from the top of the lighthouse reflects the great differences in the land-, sky-, and seascapes of this almost 200-mile stretch of water. I have also sought out interesting photographic details of each lighthouse, and I hope that these too will give the reader a more intimate experience of the buildings.

I am grateful to Captain Terry McDonald, the Coast Guard public affairs division chief, and his assistant, Chief Warrant Officer Joe Greco, for providing official permission to visit and photograph many of the lighthouses. Many Coast Guard officers and enlisted men helped me get to dozens of locations and were unfailingly cooperative. James R. Grieves, A.I.A., assisted with the technical descriptions of the architectural details, and David Ashton, the designer of the book, maintained a sharp focus on the problems to be solved and the direction to be kept. To all the persons mentioned here, my deepest thanks.

Introduction

"Nothing moves the imagination like a lighthouse," Samuel Drake said. The Chesapeake Bay, however, is not the rockbound coast of Maine or the mysterious Hebrides. It is an inland sea; once a ship has entered the Capes it is usually assured of smooth sailing, and most of the lighthouses on the Bay led a rather uneventful existence, although occasionally attempts have been made to romanticize them. The Maryland Historical Society has a pamphlet published in 1879 by A. Parlett Lloyd, *The Chesapeake Illustrated*, which describes several steamer excursions and carries advertisements for steamship companies. Lloyd describes one Chesapeake lighthouse in these terms:

And now we are upon the glorious Chesapeake! As the traveler scans the surrounding surface of the bay, a light house, called the Seven Foot Knoll, appears at no great distance. How lonely, how deserted, but yet how wakeful must be the keeper of that solitary light! Let us fancy ourselves in this lone, seemingly forsaken place during the long dreary nights of winter, surrounded by an almost impassable barrier, and miles from civilization, trembling with fear lest the huge blocks of ice that gather about and driven by the wind shake the dwelling, should demolish the seemingly weak and fragile frame that supports us!

Sevenfoot Knoll is a mile and a half from land and nine miles from downtown Baltimore! To be fair, there are many tales of shipwreck and incidents of heroism connected with the lights of the Bay, and some of these appear in the text accompanying the photographs of the lighthouses themselves.

The Chesapeake is the largest of the 500-odd estuaries in the United States and is probably the richest in both quantity and variety of its marine life. "A faire Bay," Captain John Smith called it in his *Generall Historie of Virginia*, "compassed but at the mouth with fruitfull and delightsome land." The Bay is nearly 200 miles long and varies from less than 5 to more than 30 miles wide. Like most estuaries, it is not very deep; its average depth is only about 20 feet, although in some places it exceeds 150 feet. One can sail up the Chesapeake from the Capes to the Chesapeake and Delaware Canal and never vary one's compass heading by more than a few degrees from due north.

Dozens of rivers and creeks empty into the Bay. Its total shoreline is estimated to exceed 4,000 miles. The Susquehanna, James, York, Rappahannock, Potomac, and Patuxent rivers, all on the Western Shore, were important commercial waterways until the early part of this century, and the Patapsco still is; lighthouses were built in or at the entrance to all these rivers. The low and marshy Eastern Shore became a busy area for commercial fishermen, and the lighthouse locations near its large rivers—the Chester, Choptank, Wicomico, Nanticoke, and Annemessex—were selected more for their benefit than for that of the shipper. Fishermen annually harvest more than $30 million worth of fish and shellfish from the Bay, and 6,000 merchant ships and thousands of pleasure craft every year use its protected waters.

Captain John Smith had anticipated this activity. In his *Travels and Works* he wrote: "The waters, Isles, and shoales are full of safe harbours for ships of warre or marchandize, for boats of all sortes, for transportation or fishing." Baltimore is one of the most important commercial ports in the United States, and the Norfolk naval base is one of the largest in the world. The once remote Eastern Shore of Maryland and Virginia has become easily accessible since the construction of the Chesapeake Bay Bridge near Annapolis in 1952 and the Chesapeake Bay Bridge-Tunnel, which connects Cape Henry and Cape Charles at the southern entrance to the Bay, in 1964. More than 100 lighthouses

were erected at 74 locations on the 1,688 square miles of the Chesapeake, the "mother of waters," as the Indians called it. They were all built over a period of only 120 years, from 1791 to 1910. Only 32 remain today, some in ruins and abandoned and only 3 still manned.

There are no written records of how lighthouses first came into use; undoubtedly the increase in trade, especially in the Mediterranean, and the concern of shipowners dictated their erection. Coal or wood fires on top of cliffs or man-made towers marked entrances to safe harbors. Even during the daytime the smoke from the fires could be seen from a long distance, but such beacons must have been highly unreliable.

The famous Pharos of Alexandria, completed during the reign of Ptolemy II in about 280 B.C., is the first lighthouse of which there is a written description. It was one of the wonders of the ancient world, a huge and imposing marble structure, perhaps 400 feet high. Its likeness was shown on many Roman coins, and it stood well over fourteen hundred years. The last known reference to the Pharos was made by Edrisi, an Arab geographer, a thousand years after it was built: "this structure is singularly remarkable, as much because of its height as of its solidity. . . . During the night it appears as a star, and during the day it is distinguished by the smoke." In the fourteenth century it was in ruins, probably destroyed by an earthquake. The Romans built many lighthouses in the Mediterranean and off the coasts of Spain and France. As shipping increased in Europe after the Dark Ages, more and more lighthouses were built by all the maritime nations; by 1800 there were nearly 200 in Europe.

The first lighthouse in the United States was built on Little Brewster Island in Boston harbor and was lit on September 14, 1716. A tax of one penny per ton was levied on all vessels, except coasters, entering or leaving the harbor, to pay for the maintenance of the light. George Worthylake, the first keeper, augmented his annual salary of £ 50 by acting as pilot for ships unfamiliar with the harbor. He and his wife, daughter, and two assistants, drowned two years later when his boat capsized as they were returning to the lighthouse from Boston.

Lighthouses were considered very important by the lawmakers of the first Congress: the ninth statute passed by them (on August 7, 1789) turned the titles to all 12 lighthouses then in existence over to the federal government, which became responsible for maintenance and new construction. The act also provided that "the maintenance of aids to navigation generally shall be defrayed out of the Treasury of the United States." Alexander Hamilton personally supervised their operation.

In 1800 there were 24 lighthouses in the United States, all located at entrances to harbors or estuaries. Cape Henry was the only lighthouse on the Chesapeake Bay. Arthur Pierce Middleton, a historian and author of *Tobacco Coast, A Maritime History of Chesapeake Bay in the Colonial Era*, noted: "Chesapeake Bay, with a greater volume of shipping than any other region of continental America in the eighteenth century, was the last important region to be provided with the benefits of so useful an aid to navigation [as a lighthouse], or as Governor Gooch of Virginia called it 'a noted landmark to guide the doubting mariner.' "

One of the first navigational aids placed near Cape Henry was a large wooden cross to serve as a spiritual reminder as well as a navigational guide. In the latter part of the eighteenth century buoys were placed near or on shoals at various locations in the lower Chesapeake. They were often stolen or moved by "mooncussers," bandits who profited from arranged shipwrecks. The Virginia legislature in 1774 passed a bill intended to stop this activity. It read, in part: "whereas the

taking away, removing, sinking or destroying of the buoys may have very fatal results, be it enacted therefore: That if any person shall take away or remove, sink or destroy any of the buoys, he or they, on being adjudged guilty thereof . . . shall suffer death without benefit of clergy." It is not known whether anyone was ever convicted under this law, but certainly the penalty must have given pirates some second thoughts.

The lack of lighthouses was remedied during the first half of the nineteenth century: by 1850 there were 21 lights in existence on the Bay. In addition, there were 9 lightships anchored at important locations, all which were eventually replaced by lighthouses. In the second half of the century 49 lighthouses were built in the Chesapeake Bay and its tributaries. Only 4 lighthouses were built in this century.

In 1791 it cost the government $22,591.94 to maintain the 12 lighthouses in existence. A hundred years later the expenditure, for maintenance only, had climbed to over $3 million, and the bureaucracy needed to administer the lighthouse service had grown accordingly. In 1820, when lighthouses were still few in number, the lighthouse establishment came under the personal direction of Stephen Pleasonton, who was the fifth auditor of the Treasury. He dominated the service for the next 32 years. In 1852, after a congressional inquiry into the way Pleasonton had run his department, the lighthouse service was reorganized into the Lighthouse Board, though still kept under Treasury Department jurisdiction. Half a century later another reshuffling took place; on July 1, 1903, the Board was placed in the Commerce and Labor Department. When the Department of Labor split off from Commerce in 1910, the responsibility for the lighthouses passed to a newly formed Bureau of Lighthouses, in the Commerce Department, under the direction of a commissioner of lighthouses. The commissioner's job went to George R. Putnam, an engineer and surveyor and a man of enormous administrative talents. He held the post until he retired in 1935. In 1939 the Bureau of Lighthouses was abolished and its activities taken over by the Coast Guard. After only 36 years, the service was back in the Treasury Department, which was, until recently, responsible for the Coast Guard.

George Putnam wrote: "the early lighthouses are representative of some of the best architecture in this country—simple, honest, dignified and strikingly located." The Chesapeake Bay was especially blessed with an enormous variety of architectural styles: brick towers, steel towers, stone towers, wooden towers, even small towers built on top of keepers' houses, on both land and water.

Because of the sandy or muddy bottom of the Bay and the need to locate lighthouses away from land to mark its extensive and dangerous shoals clearly, screwpile foundations were used more frequently here than in any place else in the world: 42 were built over a period of 54 years. In 1838 Alexander Mitchell, an English engineer, designed and built a new kind of lighthouse structure at Maplin Sands in the mouth of the Thames which he called a "screwpile" type. He described it as

a project for obtaining a much greater holding power than was possessed by any pile or mooring then in use; the former being nothing more than a pointed stake of considerable size, easily depressed in or extracted from the ground. . . . The plan which appeared best adapted for obtaining a firm hold on soft ground or sand was to insert, to a considerable distance beneath the surface, a bar of iron having at its lower extremity a broad plate or disk of metal in a spiral or helical form, on the principle of the screw, in order that it should enter into the ground with facility; thrusting aside any obstacles to its descent, without materially disturbing the texture of the strate it passed through, and that it should at the same time offer an extended base, either for resisting downward pressure or an upward strain.

The screwpile design was, in fact, a simple, effective, and inexpensive means of anchoring a lighthouse—except where there was a lot of floating ice, as many keepers on the Chesapeake would learn, to their great distress. It was especially effective in inland waters, where the building was not exposed to heavy seas, but even there the structures had to be protected against ice by strategically located icebreakers or riprap stone piles. The Maplin Sands lighthouse, however, lasted until 1932, when its foundation was undermined by changes in the sandbanks on which it stood.

The fifth auditor of the Treasury, Stephen Pleasonton, was not impressed with the new device. When the superintendent of lighthouses in New London, Connecticut, sent him a drawing of a screwpile lighthouse in the early 1840s and suggested its use in the United States, he wrote back, "I have no idea that such a structure would stand a single winter." Nevertheless, a screwpile lighthouse was built in 1848-1850 by Major Hartman Bache, an army engineer, on Brandywine Shoal in Delaware Bay. This light was in use until 1914, when it was replaced by a caisson-type structure (see below).

Because so many screwpile lighthouses were built on the Bay, it might be interesting to hear Major Bache's account of his next project, carried out in 1854, which is given in the Lighthouse Board annual report for 1855. It was the supervision of the construction of the first screwpile light in the Chesapeake, at Pungoteague River (which, incidentally, only stood for 459 days, the shortest-lived lighthouse in the Bay):

The structure now completed consists of seven hollow iron piles with conical bases, disposed at the angles and centre of a hexagon, sunk ten feet eight inches into the bottom and rising ten feet above the water, which is 7½ feet deep at low tide, being connected by spider-web braces, and also cross-braces between each two consecutive periphery piles, and between each periphery pile and the centre-pile. The piles and the collars and coupling-sleeves &c., are of cast-iron; the braces of round rolled iron. On the piles as a foundation rests the dwelling, also hexagonal, of one story of nine feet, with a gallery all round, from the centre and floor of which rises a tower of the same figure eight feet in diameter, of such height that, with the lantern, the focal plane has an elevation of about fifty feet.

The dwelling, thirty feet in diameter, is conveniently divided into a sitting-room, sleeping-room, store-room and kitchen. Two sash-doors and four windows open on to the gallery, to which there is a convenient ascent from the water by an iron ratline ladder. The ascent of the tower is made through a door from the sitting-room, and by an easy flight of stairs to the lantern, round which there is also a pathway.

A boat of proper size is furnished, with hoisting apparatus to raise it by the power of one man to the level of the gallery, and the structure protected by a lightning-rod. The iron-work is painted red; the dwelling, tower and lantern, inside and outside, white; and the gallery floors, roof of house, and lantern &c., Ohio brown. . . . The lighting aparatus is of the fifth-order Fresnel, illuminating the whole horizon by a Cornelius lamp, but it will be replaced by one of the same order, illuminating seven-eighths of the horizon by a constant level lamp.

All the screwpile lights on the Chesapeake and its rivers were essentially alike; they varied only in size, in number of piles used, in type of bracing, and in style of superstructure. Most of the sites on which they stood were procured through cessions made by the state legislature and were five-acre submarine tracts, i.e., circles with a 263.3-foot radius.

The occasionally disastrous experiences with screwpile lights during severe winters made the Lighthouse Board painfully aware of the need for more solid foundations for offshore structures, and 12 lighthouses of the caisson type mentioned above were built in the Chesapeake, all of which are still in use. These were far more expensive, for huge cylindrical foundations had to be constructed, towed to the site, and sunk in

place while the sand or mud was being pumped out from the center of the caisson. Once in place, however, they proved inexpensive to maintain and immune to the worst the Bay could offer in wind and water. Caisson lighthouses actually replaced five screwpile lighthouses burned or wrecked by ice.

The early stone or brick lighthouses on the Chesapeake were always built on land and to the same specifications: a 30-foot tower, narrowing in diameter from 17 feet at the bottom to 9 feet at the top; a 20- by 34-foot house with a small porch or kitchen; and an outhouse and well. Nevertheless, the construction superintendent reported during the building of Fog Point lighthouse in 1827, "taking the plan altogether, I think it better calculated for convenience and comfort to the keeper than any other on the Chesapeake Bay." He pronounced the construction contract fully complied with, "notwithstanding all the privations incident to this barren insulated situation." Fog Point is located on Smith Island, even today one of the more remote spots on the Chesapeake.

Up to the eighteenth century coal and wood fires were burned on the tops of lighthouse towers, but by 1700 candles and lamps burning whale and fish oil began to replace them. It is known that oil lamps illuminated the Eddystone lighthouse on the southern coast of England as early as 1759. Tallow candles were used in the first lighthouses built in America. The first scientific advance in illumination occured in 1784, when Aimé Argand, a Swiss engineer, invented an oil burner which used a hollow cylindrical wick and a glass chimney to increase the draft. The brightness of the flame was greatly improved, and soot and smoke could be kept to more manageable proportions.

Although they became popular in England shortly after their invention, the Argand burners were not used in the United States until Winslow Lewis, a former ship captain from Boston, invented, and in 1812 officially registered, his "patent magnifying and reflecting lanterns." Lewis had convincingly demonstrated at the Boston lighthouse that his system, using modified Argand burners and parabolic reflectors, was infinitely superior to the so-called spider lamps, then in use. The spider lamps used four wicks in a flat pan of oil and gave off burning and stinging fumes which made it impossible for the keeper to remain for more than a few minutes with them. In addition, Lewis' method used only about half as much oil, and the cost-conscious fifth auditor was very much impressed by that fact.

Congress duly appropriated $60,000 to buy Lewis' patent and to permit him to install his system in all the 49 lighthouses in the country. The contract also stipulated that he was to maintain those lights for a period of seven years. It took Lewis only three years to perform the conversions, and as new lighthouses were constructed he outfitted them with his lamps and reflectors. At the Bodkin light, built in 1822, the first in Maryland, he charged $1,000, including installation, and supplied the following: 13 patent lamps with 16-inch reflectors, 2 spare lamps, double-tinned oil butts sufficient to hold 600 gallons of oil, 1 lantern canister, 6 sawhorses, 1 iron trivet, 1 stove and funnel, 1 oil feeder, 1 torch, 1 wick box, 1 tube box, 6 wick formers, 1 oil carrier, 2 pairs of scissors, and 2 files. The contract stated that he would, "in a faithfull and workmanlike manner," have all these supplies in place within a month after the building was completed. (His invoice mentions that he also left two wrenches, a hammer, and a "soddering machine," at no charge.) Lewis eventually went into the lighthouse building business and constructed several lighthouses in Maryland and Virginia.

In 1822, the year in which the Bodkin light was first lit, Augustin

Fresnel, a French physicist, invented a remarkable lens that featured a unique prism and a powerful magnifier. Fresnel died in 1827 at the age of forty-five, before he saw his lenses in use. They eventually were installed in lighthouses throughout the world and are still in use today in many places. It may be safely said that Fresnel made the single most outstanding contribution to the design of lenses and helped light the way for mariners everywhere. His lenses were eventually manufactured in seven sizes, or orders:

Order	Inside Diameter	Height
1st	72 7/16 inches	7 feet 10 inches
2d	55 1/8 inches	6 feet 1 inch
3d	39 3/8 inches	4 feet 8 inches
3 1/2	29 1/2 inches	3 feet 8 inches
4th	19 11/16 inches	2 feet 4 inches
5th	14 3/4 inches	1 foot 8 inches
6th	11 3/4 inches	1 foot 5 inches

Alan Stevenson, the celebrated Scottish lighthouse engineer, described the largest, a first-order lens, this way:

Nothing can be more beautiful than an entire apparatus for a fixed light of the first order. It consists of a central belt of refractors, forming a hollow cylinder six feet in diameter and thirty inches high; below it are six triangular rings of glass, ranged in a cylindrical form and above a crown of thirteen rings of glass, forming by their union a hollow cage, composed of polished glass, ten feet high and six feet in diameter. I know of no work of art more beautifully creditable to the boldness, ardor, intelligence and zeal of the artist.

Most of the lighthouses in the Chesapeake Bay were eventually fitted out with the smaller fifth-order lenses. A few still have them today, although electric light bulbs have been substituted for the wicks.

It took years for the lighthouse service to adopt the new lenses. Stephen Pleasonton was a penny-pinching, conservative bureaucrat who knew a great deal about cost accounting but very little about light, lighthouses, or the needs of navigators. He had leaned on Captain Lewis for technical advice for decades, and Lewis, with his business interests to protect, was naturally unwilling to experiment with new-fangled foreign gadgets. Eventually both men came under heavy criticism because of their intransigence, and in 1838 Congress dispatched Commodore Matthew Perry to Europe to evaluate the lighthouse systems there and to purchase some of Fresnel's lenses. They were later installed at the two Navesink, New Jersey, lighthouses. But by 1851, nearly 30 years after Fresnel's discovery, only three lighthouses in the United States were equipped with his lenses, and it had taken a special act of Congress to get those three installed.

The legislators finally had enough of Pleasonton's foot-dragging, and in 1851, under pressure from shipping interests and insurance companies, Congress set up an investigative board to delve into all aspects of the lighthouse service. The board was composed of two naval officers, two army officers, one civilian "of high scientific attainment," and a junior naval officer who acted as secretary. One year later, in 1852, the board returned a scathing 760-page indictment of Pleasonton's department and his short-sighted policies. Congress, impressed, created a nine-member Lighthouse Board composed of the members of the investigative commission and a few additional ones.

The country was divided into lighthouse districts (the "fifth district" designation is still used by the Coast Guard, and the Chesapeake Bay falls within its boundaries), and the Board went full steam ahead with its plans to overhaul the service. In a remarkably short period of time it raised the United States lighthouse establishment to a level com-

parable to that of other countries, especially those of western Europe. New techniques, equipment, and methods were tested, and many subsequently adopted, to help make piloting and navigation safer than it had ever been.

Fish, whale, and vegetable oils were used as fuel in the oil wick lamps, and improvements in these illuminants were agonizingly slow. But early in the twentieth century Arthur Kitson developed the incandescent oil vapor, or IOV, lamp, and it was widely adopted by the lighthouse service. Instead of an open flame, in his design the oil was vaporized in a container, and when mixed with air and pumped up under pressure, it became an inflammable gas which burned more steadily and gave a much brighter flame than the oil wick lamps. But even at this point lighthouses were being automated; dissolved acetylene gas, stored in containers, could easily be controlled with clocks to turn the lights off and on, and electricity as a source of power was gradually introduced after 1900 (Trinity House, England's lighthouse bureau, had experimented with electricity at South Foreland light as early as 1858). When the Coast Guard took over the Bureau of Lighthouses in 1939, almost every lighthouse in America had been converted to electricity, and the days of the open flame and the "wickie" trimming the lights were over.

The Coast Guard is now proceeding on schedule with LAMP, their Lighthouse Automation and Modernization Program. It costs about $100,000 to prepare a light station for automated operation, and as the annual savings in salaries and supplies amount to nearly $25,000, it takes only four years to recover the investment. There are now fewer than 150 manned lighthouses in the United States, and it is anticipated that by 1980 fewer than 40 will be occupied by "resident personnel." Only three lighthouses on the Chesapeake Bay are still manned by Coast Guardsmen: Cape Henry, Cove Point, and Thomas Point Shoal.

Since George Worthylake became keeper at Boston light in 1716, there have been thousands of civilian keepers (of whom, incidentally, more than 250 were female). There are now only three civilian lighthouse keepers on duty in the Coast Guard, none on the Bay. The keepers were obviously most important to the efficiency and reliability of the lighthouse system, but the service seldom let them know it. Thomas Jefferson acknowledged the need for dependable men when he wrote, "the keepers of light houses should be dismissed for small degrees of remissness, because of the calamities which even these produce." Stephen Pleasonton in one letter referred to "the ignorant people such as our keepers generally are," and the men were frequently treated and admonished as though they were children. Although the job eventually came to have a degree of security, arbitrary dismissals and replacements by political appointees were not infrequent.

The keeper's pay varied from place to place, but it was always low. On the other hand, the work, although monotonous, was seldom dangerous or strenuous. A keeper on the Chesapeake in the 1890s could earn as much as $640 annually; his assistant's pay ranged from $440 to $460, depending on experience. Sometimes the complaints about low salaries were echoed by the keepers' superiors: in 1806 the collector of customs in Norfolk wrote to Albert Gallatin, the secretary of the Treasury, about the keeper at Cape Henry, who was then earning $200 per year: "Keeper is in my opinion deserving a better salary as no emoluments can be derived from gardens, or any ways except by a few fish at times, the place is so disagreeable by the drifting of the sand, that very few people visit it, your eyes are in danger and all you eat is gritty."

The request was approved. Many keepers on shore stations were able to farm and raise livestock, and those on lighthouses surrounded by water could augment their diet and budget by catching oysters, crabs, and fish.

In addition to their pay, the keepers were also annually issued many staples. The allowance in 1882, for example, consisted of 200 pounds of pork, 100 pounds of beef, 50 pounds of brown sugar, 2 barrels of flour, 24 pounds of coffee, 10 gallons of beans, 4 gallons of vinegar, 2 barrels of potatoes, 50 pounds of rice, and 13 ounces of mustard and pepper. The keepers were issued bulky instruction books filled with advice about their personal conduct and engineering drawings of the light apparatus and fog signal machinery. Always there was the dual emphasis on cleanliness and frugality: "No parts will be painted to give them a clean appearance when there is ample paint to protect the parts and same are dirty or dingy. They shall be scrubbed."

Lighthouse keepers were, and are, required to keep a log of their activities, the weather conditions, and any unusual occurrences. Almost without exception they describe the monotony of the keeper's household chores: cleaning station, scrubbing paint, cleaning windows. One of the keepers at Great Shoals light, at the entrance to the Wicomico River, managed to enliven his log with personal and philosophical references. His name was W. H. McDorman, and excerpts from his log, beginning in December, 1923, give some insight into his routine:

Monday	15 December	Washday and other housework.
Tuesday	16 December	Scrubbing kitchen floor and sawing wood.
Wednesday	17 December	Shining brass and other work.
Thursday	18 December	Relighted all beacons.
Friday	19 December	Regular routine of work.
Saturday	20 December	Not much doing.
Sunday	21 December	Day of rest.
Monday	22 December	Finished painting boat and swept all rooms.
Tuesday	23 December	Miscellaneous work.
Wednesday	24 December	Cleaning and sweeping tower and steps.
Thursday	25 December	Xmas — Working and other observances.
Friday	26 December	Clean and polish stove and other work.
Saturday	27 December	Coldest day of the season — ice as far as you can see.
Sunday	28 December	Reading and other exercise.
Monday	29 December	Enameled keeper's bed.
Tuesday	30 December	Fog signal going since 1 A.M.
Wednesday	31 December	Usual work at station. Good Bye Old Year. Your duration has been mingled with Sorrow, Tears & Heart aches & Joy. Good Bye for Ever. I hope to live to write this same inscription for 1924. But I hope it will be more pleasant so good Bye never to see you again.
Thursday	1 January	Usual work for the New Year.
Friday	2 January	Painted pilings down to low water.
Saturday	3 January	Still painting and I am very tired.
Sunday	4 January	This is rest day except necessary work to be done.
Monday	5 January	One tug boat and a barge passed at 7:30 P.M.
Tuesday	6 January	From one thing to another; keep up of station.
Wednesday	7 January	Dusted station today.
Thursday	8 January	Boat running fine. Can't be beat.
Friday	9 January	Fixed and painted tank in storage room. Done a good job.
Saturday	10 January	Went ashore for mail.
Sunday	11 January	Usual work. Two visitors today.
Monday	12 January	Almost blowing a hurricane, East wind and rain.
Tuesday	13 January	Painting floor timbers.
Wednesday	14 January	Usual work in bad weather.
Thursday	15 January	Tender *Arbutus* delivered 4 gallons of varnish and 2 mattresses.
Friday	16 January	Filling and trimming lamps.
Saturday	17 January	Put in a big days work washing and cleaning tower panes.
Sunday	18 January	Usual work of different objects.
Monday	19 January	Painted kitchen one coat and on shore for provisions.

Usually the logs of a light station were turned in to the Bureau when they were full. However, notations were often so sparse that even a slim ledger could serve for ten years or more. One of the log books at Cherrystone light was kept at the station after it was filled up and served as a notebook for subsequent keepers and their guests. The original neatly penned official version was started in 1886, and the entries were of the common variety: cleaned windows, scrubbed paint, and so on. But in 1897, during Christmas holidays, two young visitors to the lighthouse made their own notations on any white spaces they could find between the entries. One of them was the daughter of the head keeper, who was visiting with her father for a few days. She didn't like it much: "We came here on Tuesday and will be glad to get off Friday. Today is Wednesday, it is now half past six o'clock, the time passes so slow. I do not see how I can stand it until" On Thursday she wrote: "Julia Kirwan, sweet seventeen, wrote this while here to pass the time away, it is so very lonesome." On the day she left, her friend, perhaps feeling some guilt over defacing government property, wrote: "Whoever reads this book of knowledge will end their days in Sing Sing College."

These feelings of loneliness were echoed some years later by a young assistant keeper at Cherrystone light, Oscar Daniels. He wrote in 1909, "a man had just as well die and be done with the world at once as to spend his days here." He signed his note "All Alone." His depression did not lift. On his birthday he wrote, "the assistant keeper at Cherrystone lighthouse is now 24 years of age. Nasty day, no chance of going home today, hope I will soon get there." And on the following Sunday: "I pity a poor fellow who spends his Sundays on this old light. I would like to go home just about now and a little while from now too I guess." On the last page, between the careful notations made by the first keeper, in the empty space between "standing watch" and "the sabbath was respected," he wrote this bit of doggerel:

I am sitting on the light
at this woeful hour of night (3 A.M.)
and the fogbell is a-ringing overhead
seems to me this fog should stop
if it does in bed I'll flop.

The duties of lighthouse keepers on the Chesapeake Bay are still monotonous, but frequent rotation and long off-duty periods help relieve the loneliness and boredom of the keepers at the three remaining manned stations.

All the other lights are completely automated now; some lights are powered by long-lasting storage batteries, while others are connected to shore with electrical cables. Some fog bells and foghorns sound continuously; others are silent during the Chesapeake's relatively fog-free summer; some can be activated by remote control from nearby Coast Guard stations on shore. Even the light system in some lighthouses is so constructed that a new bulb will immediately swing into position should the old one burn out.

The lighthouses on the Chesapeake Bay once numbered 74. Today, two are owned by museums, two are in private hands, several are in ruins and abandoned, and many have completely disappeared. The growing interest in our maritime heritage and the need for historic preservation will undoubtedly benefit the 32 lighthouses on the Bay that are still essentially intact. "No place is more convenient for pleasure, profit, and man's sustenance," Captain John Smith wrote of the Bay three and a half centuries ago. The lighthouses on the Chesapeake helped make it so. The following pages give what is known of their history and pictures those which still exist. Would there were more.

Standing

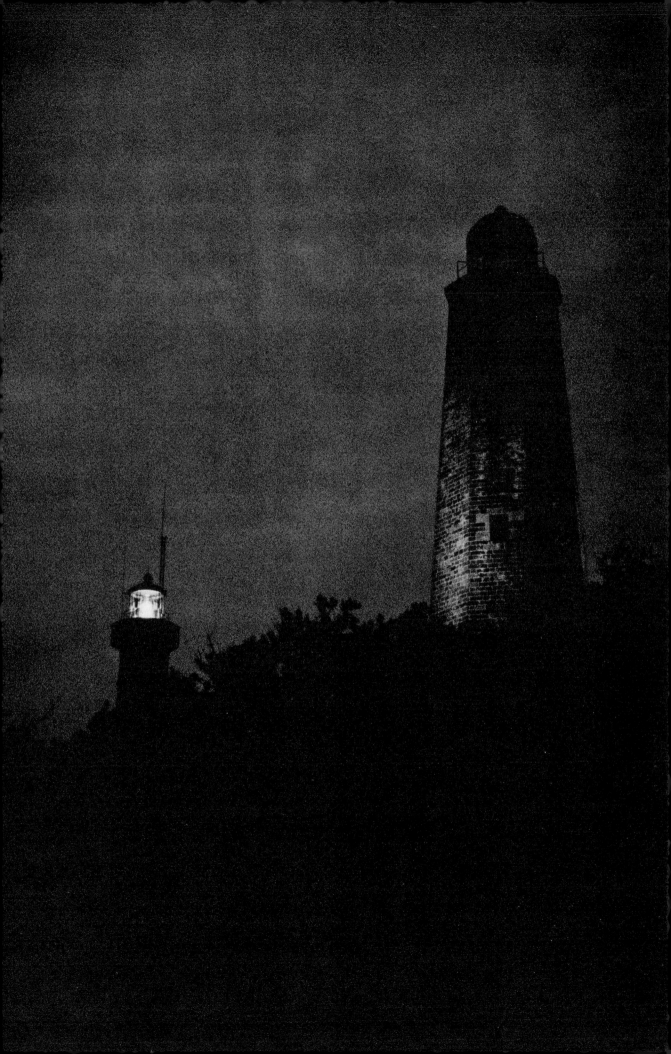

The Capes enclosing the Chesapeake Bay, Henry and Charles, were named after King James' two sons, and it is fitting that the lighthouses on Cape Henry should be the first lights to be described in this book, for one of them is also the oldest on the Bay. On August 7, 1789, the first Congress of the United States made provisions for transferring the 12 lighthouses then in existence from the jurisdiction of the states to the federal government and authorized the immediate construction of Cape Henry lighthouse.

Governor Randolph of Virginia wrote to George Washington on December 18, 1789, and offered assistance: "The State some years ago placed upon the shore at Cape Henry nearly a sufficient quantity of materials to complete such a light-house as was at that time thought convenient, which have been in the course of time covered by sand. Measures are taking to extricate them from this situation." He then offered to sell the stones and cede the land to the United States, but the stone had been buried so deep by the drifting sands that its recovery was not economically feasible, and new materials had to be purchased. The contract to build the tower was signed by Alexander Hamilton, and awarded to one John McComb, Jr., "of the state of New York, Bricklayer."

The height of the octagonal sandstone tower was to be 72 feet, but the foundation had to be placed much lower than anticipated—20 feet below the water table, in fact—which necessitated certain other engineering changes; when measured after it was completed in 1792, it was 90 feet high. It cost $15,200; a local man, Laban Gossigan, became the first keeper.

Early in the Civil War Confederate guerrillas destroyed the lantern. It was replaced in 1863, and until the end of the war a military guard was posted at the station. By 1872 cracks had appeared in the walls of the tower, and the Lighthouse Board recommended that a new lighthouse be built because the old one might be "thrown down by a heavy storm." In 1879 construction was begun on a new tower, to be 165 feet high, made of cast-iron plates backed by masonry walls. It was finished in 1881 at a cost of more than $125,000.

The new lighthouse stands 357 feet southeast of the old tower. It was provided, like the Cape Charles light across the Bay, with a huge first-order Fresnel lens. Five concentric wicks in oil lamps were used; incandescent oil vapor lamps burning kerosene were introduced in 1912, and in 1923 the lighthouse was electrified. In 1929 Cape Henry became the first radio-distance-finding station in the world. The light flashes the letter "U" in Morse code, a dot-dot-dash pattern at an intensity of 80,000 candlepower.

The old lighthouse tower was acquired from the government in 1930 by the Association of Virginia Antiquities and has been preserved and restored to commemorate the landing, on Virginia soil, of the first English settlers.

Looking southeast from the new tower
toward the Atlantic Ocean in early
morning fog.

Prisms in the huge first-order Fresnel lens
(largest on the Bay) in the newer tower.

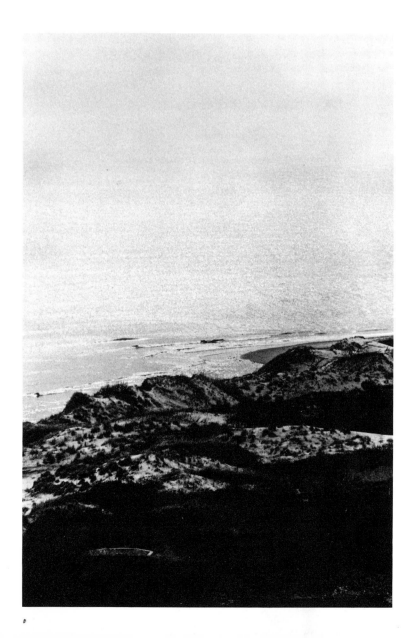

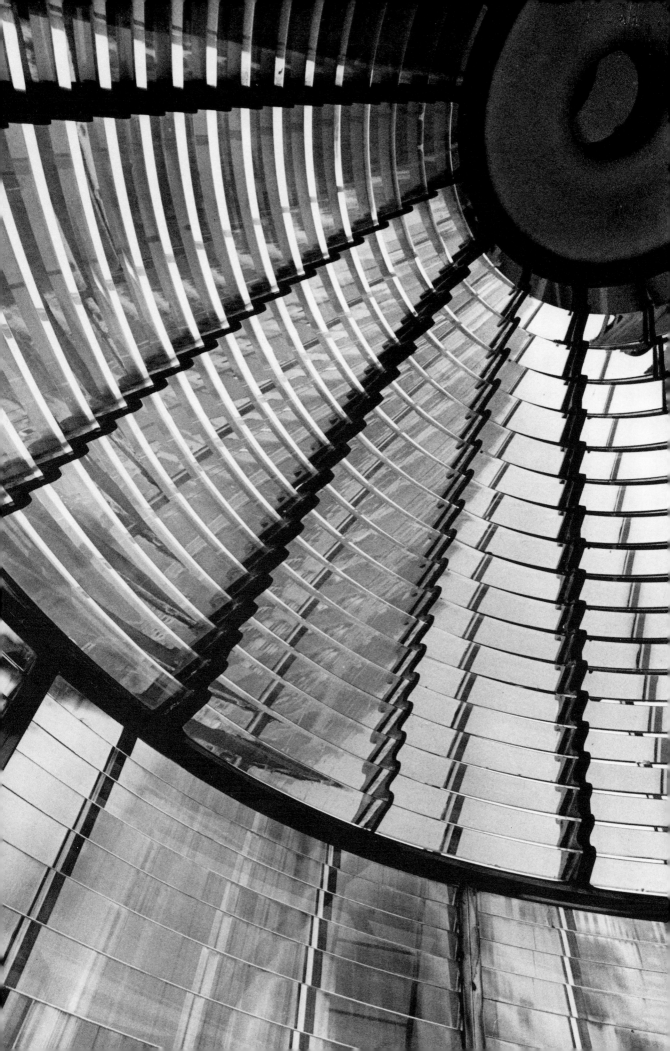

Entrance to the octagonal tower, with
semicircular pediment arch and
decorative frieze.

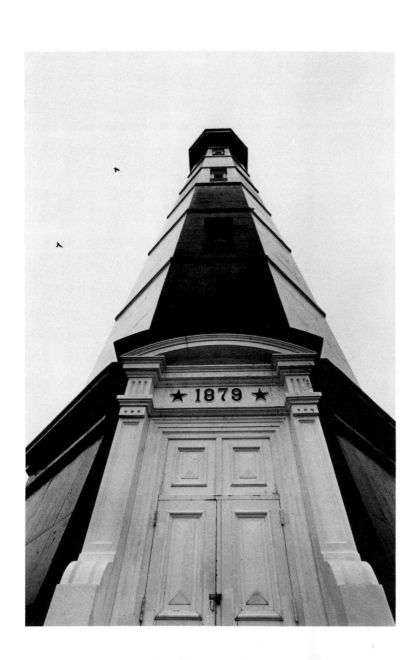

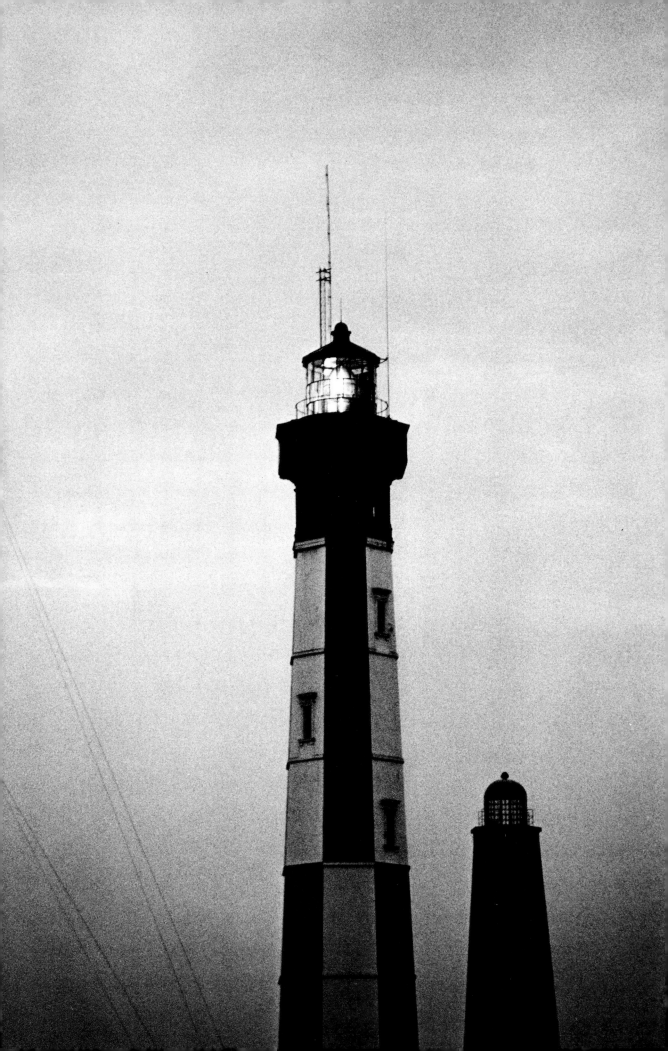

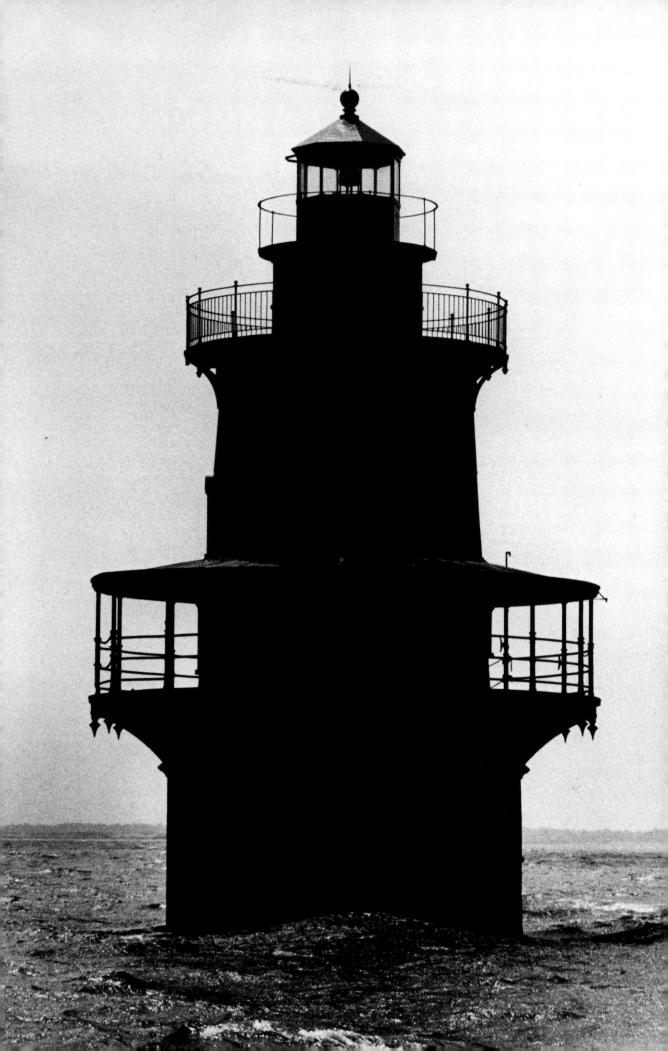

Newport News Middle Ground

The Middle Ground is a shoal in the middle of Hampton Roads, the world's foremost bulk cargo harbor, an ice-free port with more than 30 miles of improved waterfront and hundreds of piers and wharves, dominated by the activities of the United States Navy.

The Lighthouse Board requested the erection of a lighthouse here in its 1887 annual report to Congress: "Vessels leaving the docks at Newport News drawing 24 feet of water invariably pass to the southward of the Middle Ground, and because of the several changes of course masters now hesitate to leave their berths for sea on very dark or foggy nights. To obviate the necessity for thus losing much valuable time a light-house and fog-signal should be established on the Middle Ground, near Newport News, or in the vicinity of Newport News at such a point as may be selected by the Board." A concrete-filled caisson lighthouse 26 feet in diameter was built in 15 feet of water. The conical tower, 52 feet high, contained three stories, a basement, and the light lantern. It was completed in 1891 at a cost of $50,000.

A white light still flashes every six seconds from the brown lighthouse, which was automated in October, 1954, and from September 15 to June 1 a fog bell sounds one stroke every 15 seconds, 24 hours a day, fog or no. Newport News Middle Ground is one of twelve caisson-foundation lighthouses built on the Chesapeake and is the oldest of this kind in Virginia waters.

The sun reflected off the choppy waters of Hampton Roads.

The cast-iron cleat used to secure the falls of the station boat, suspended in davits when not in use.

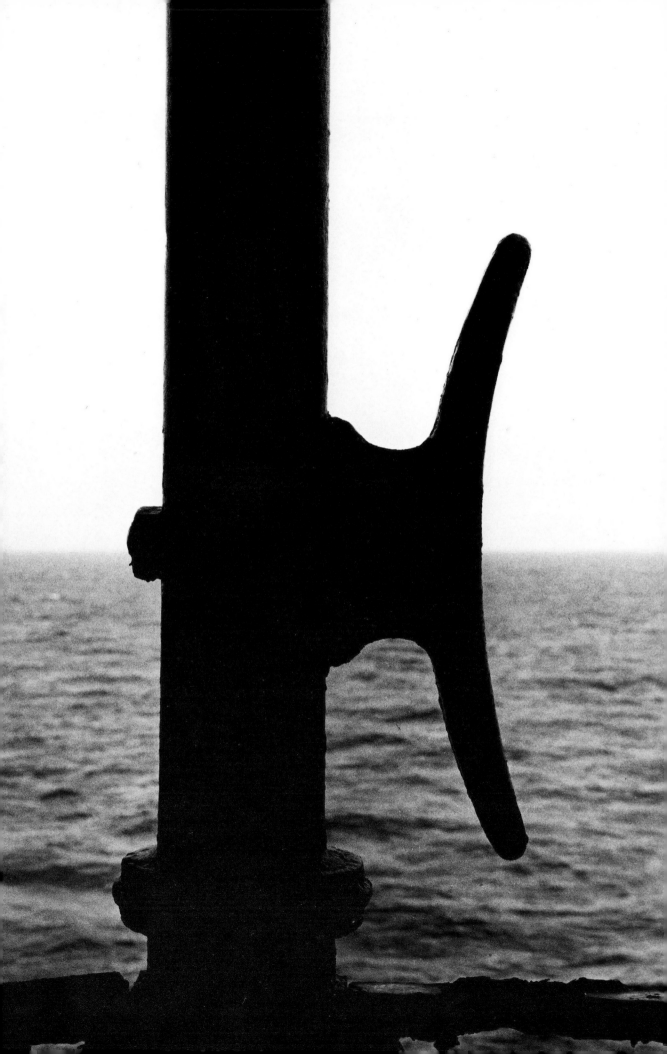

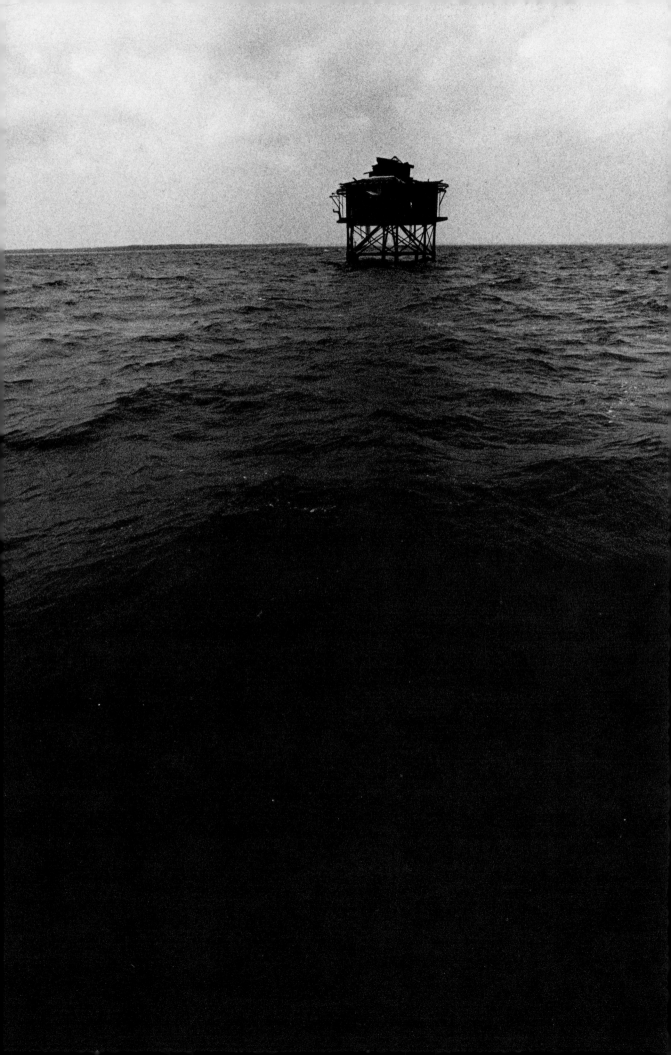

White Shoal

The abandoned White Shoal lighthouse still stands, although in decrepit condition, in the James River, seven miles from its mouth. The James, almost 300 miles long, is one of the longest rivers in Virginia, although it is only navigable to Richmond, 78 miles above its mouth.

This screwpile lighthouse was built in 1855, at the same time as two others in the river, Deep Water Shoals and Point of Shoals lights, both long since dismantled. White Shoal light was described by the Lighthouse Board in 1869 as being "of the oldest and most inferior design." Inferior or not, it still stands, 100 years later, at its original location. It is one of two lighthouses on the Bay which are privately owned. Several are owned and maintained by the State of Maryland, and two have been purchased by museums for reconstruction.

The lighthouse was completely rebuilt in 1871, and until it was sold by the federal government and discontinued, it showed a fixed white light from a fifth-order Fresnel lens. The hexagonal structure is located in one foot of water, on the lower end of the shoal, and is 33 feet high. The fog bell, long since removed, sounded one stroke every 10 seconds, when required.

Gulls disturbed from their nests in the abandoned lighthouse.

Board-and-batten privy, suspended over the water.

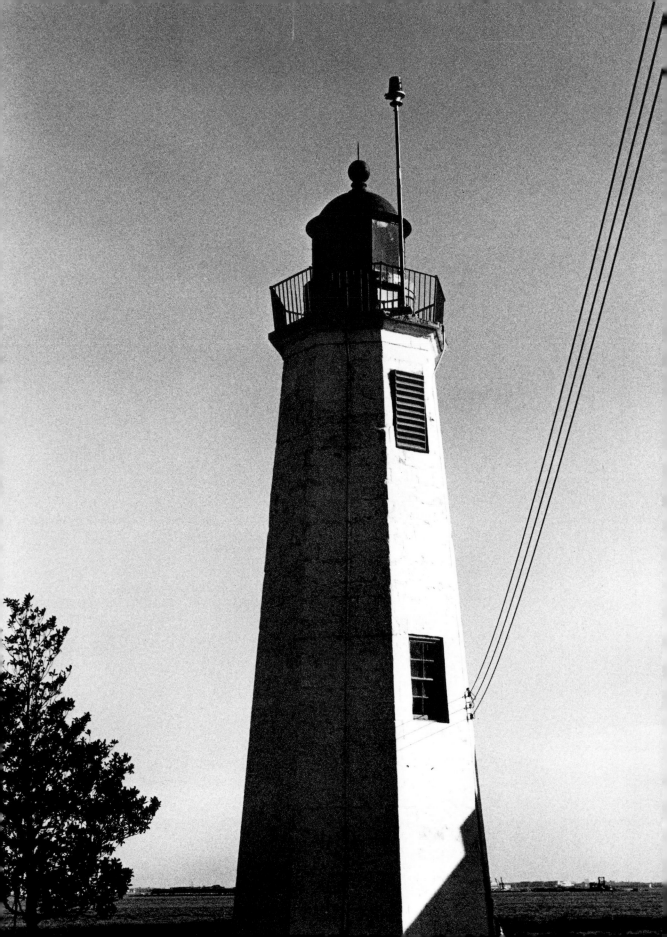

Old Point Comfort

In *The American Coast Pilot*, a book of sailing directions published by Captain Lawrence Furlong in 1800, Old Point Comfort is mentioned in a footnote: "A law passed the Congress of the United States, April 27, 1798, which enacts: 'that as soon as a cession shall be made by the State of Virginia to the United States of the jurisdiction over a tract of land proper for that purpose, the Secretary of the Treasury . . . is hereby authorized to provide, by contract, to be approved by the President of the United States, for building a lighthouse on Old Point Comfort, in the said State, and to furnish the same with all necessary supplies.' " The captain then commented: "The building of the house alluded to has never commenced, and we wish, for the security of navigation, that the important work may soon be undertaken, for the safety of our mariners, and benefit of commerce. We hazard an opinion that the necessary cession of the land has not been made." In a subsequent issue of the *Coast Pilot* Captain Furlong wrote impatiently that "the building of the lighthouse has at length commenced, and we wish that it may soon be completed." Old Point Comfort light was completed the following year, in 1802, and so became the second oldest lighthouse on the Chesapeake.

The lighthouse is located on the grounds of old Fort Monroe at the entrance to Hampton Roads and is frequently visited and photographed by tourists. The Bureau of Lighthouses recognized this fact early in this century: records note that 63 assorted plants, 8 packets of flower seeds, a lawnmower and 150 feet of garden hose were furnished the keepers for improving and beautifying the grounds. The lighthouse was briefly captured by the British fleet under Admiral Cockburn in 1812 and used as a watchtower.

The remarkable state of preservation of Old Point Comfort lighthouse is partly the result of the excellent care of its keepers (it was not automated until January, 1973) and partly the result of the fact that it was built several hundred feet from the water, thus escaping undermining and outlasting many other more recently built lighthouses whose builders did not take this precaution.

The flashing red light on the 54-foot tower is now triggered by a photoelectric cell. The keeper's house has been converted to apartments for the use of Army personnel stationed at the fort. The fog bell clangs one stroke every 10 seconds in thick weather, but it has been moved some 200 yards away from the tower and now sits on a knuckle of the sea wall.

Late afternoon, looking across Hampton
Roads toward Norfolk.

Tower stairwell of hand-hewn stone,
looking up toward the lantern.

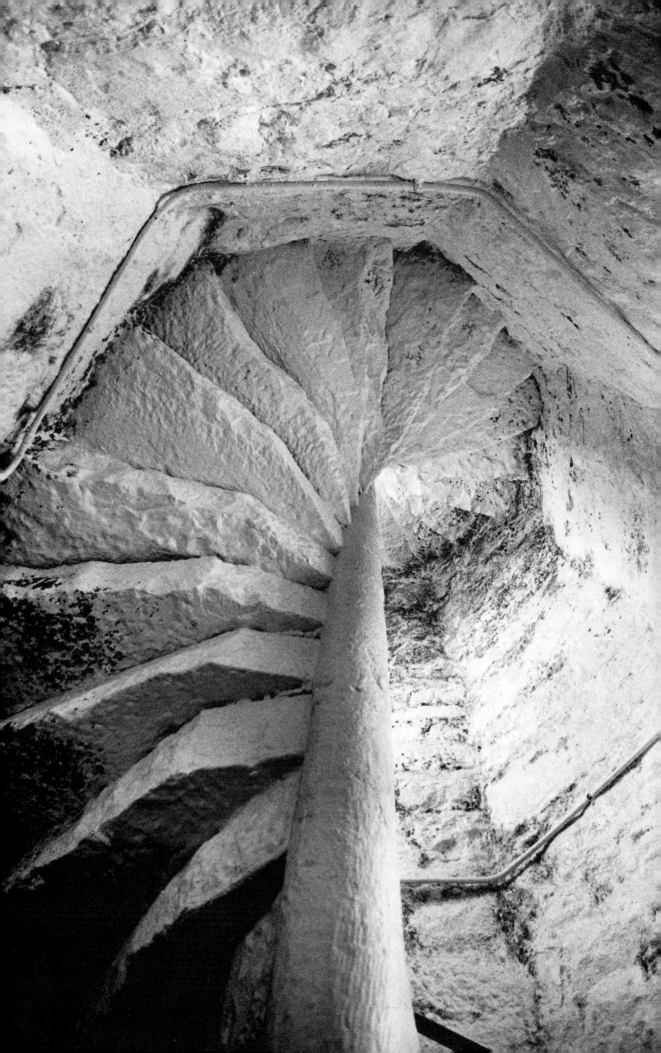

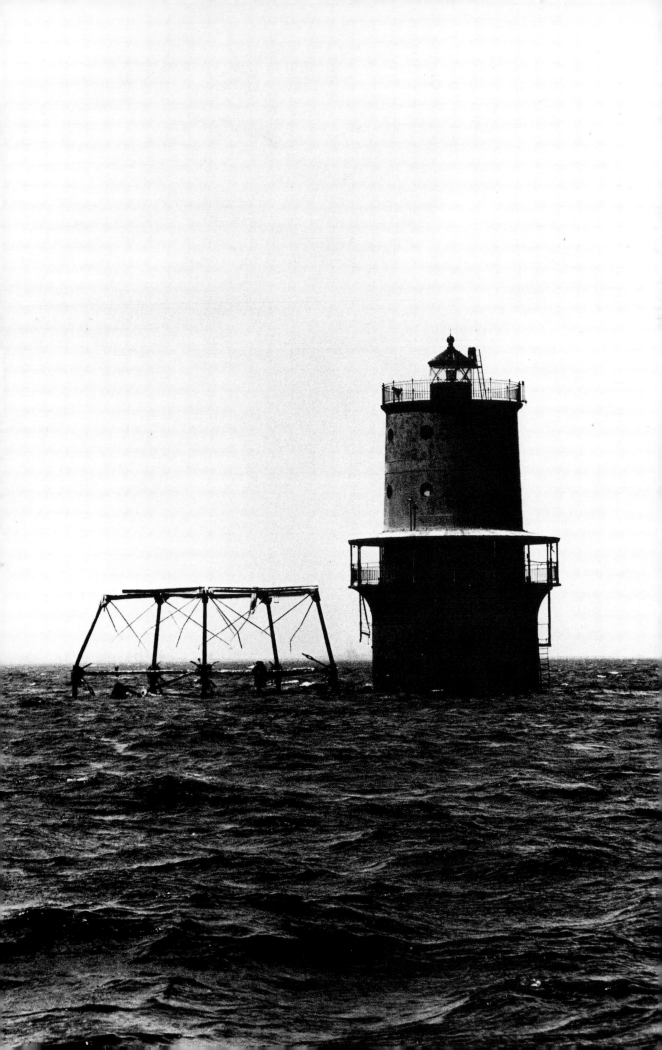

Thimble Shoal

One of the most important lighthouses on the Chesapeake is Thimble Shoal, at the entrance to Hampton Roads. It has had more than its fair share of bad luck. The first lighthouse on the shoal was built in 1872. It was of the screwpile design which had proven satisfactory in many other locations on the Bay. Eight years later, in 1880, the light was destroyed by a fire of unknown cause, but the lantern and the lens were recovered by divers, and the lighthouse was rebuilt in 55 days. The reconstruction was so speedy partly because of its important location and partly because the iron foundation pilings were intact. The new building was also a hexagonal screwpile lighthouse with a small (fourth-order) Fresnel lens, but it got two fog bells, one on the north and one on the south side of the structure, which, when required, were struck simultaneously every five seconds.

In 1891 a steamer ran into the light and did considerable damage, and on April 14, 1898, a coal barge grazed it. But the biggest catastrophe occurred on December 27, 1909, when the *Malcolm Baxter, Jr.*, a four-masted schooner being towed by a tug to Norfolk, rammed the lighthouse. The schooner drifted clear, but the stove in the keeper's quarters overturned and set the wooden building ablaze instantly. It was totally destroyed. The keeper and his two assistants managed to lower a boat and were picked up by the crew of a Navy cruiser anchored in Hampton Roads.

This time the rebuilding took a little longer—five years. On December 1, 1914, a new 55-foot tower, built on a caisson foundation, was commissioned at the shoal. The caisson, which weighted 260 tons, was assembled in Berkeley, on the nearby Virginia shore, towed to the site, and sunk in place. A three-story cast-iron tower was erected on this foundation for the keeper's quarters and the light. It cost nearly $100,000 to build, and stands today next to the spidery remains of the old screwpile lighthouse. The lighthouse was automated in 1964 and still flashes a white light every two and one-half seconds. It is ironic that this strong structure, obviously well able to withstand collisions and relatively fireproof, escaped all catastrophe in its 60-year history.

Remains of the screwpile foundation of the old lighthouse.

Unusual cast-iron mullions and diamond-shaped panes of the lantern.

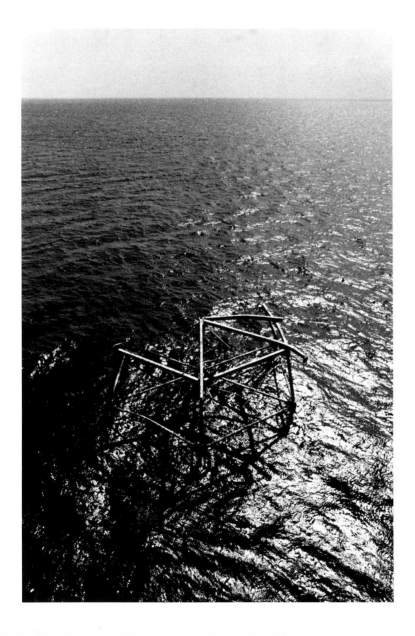

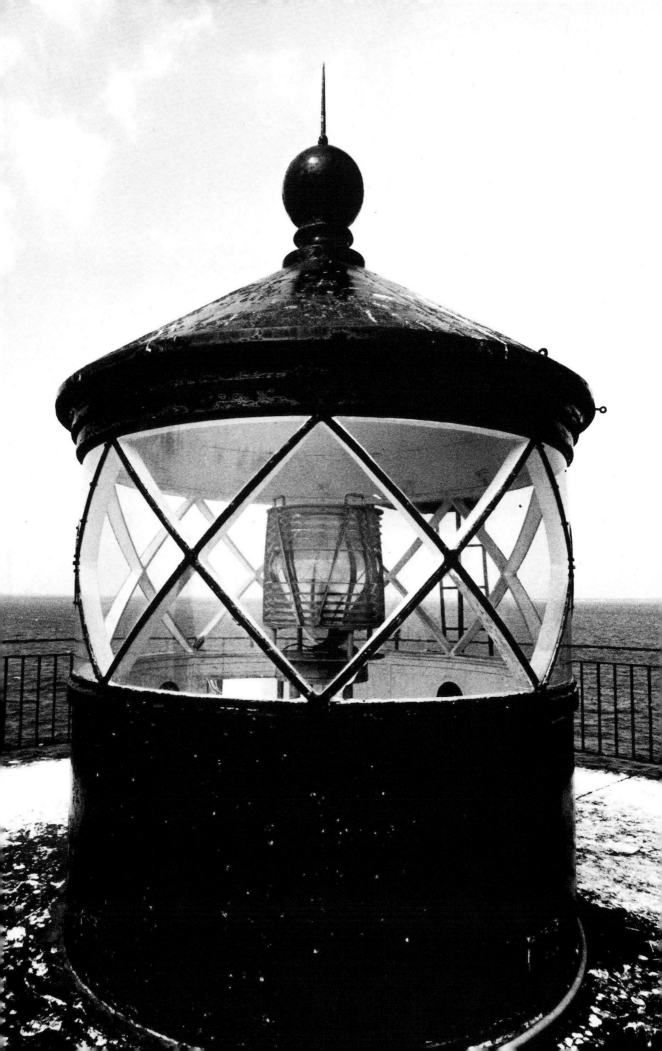

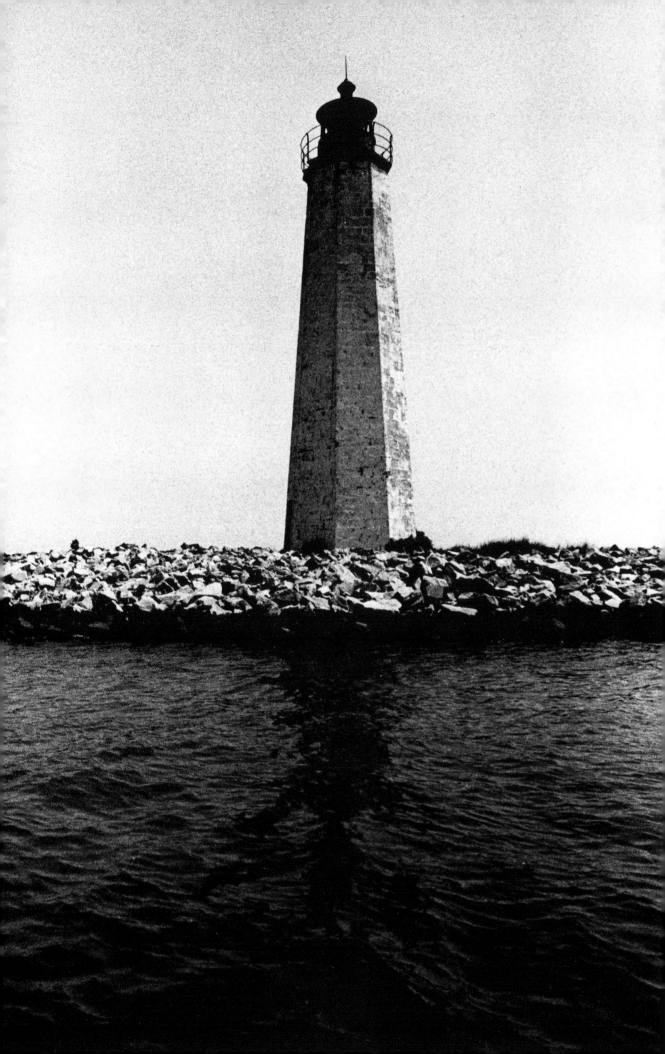

New Point Comfort was the fourth lighthouse built on the Chesapeake Bay. It still stands, 63 feet high, near the northern entrance to Mobjack Bay, on the western shore of the Chesapeake. Congress in 1801 appropriated $5,000 for its construction. Two acres of land were purchased for $150 in 1802, and the lighthouse was completed in 1804. Thomas Jefferson, then president, personally approved the appointment of Elzie Burroughs as keeper on November 11, 1804.

An unusually lengthy and detailed report on New Point Comfort light was submitted to the secretary of the Treasury in 1852 in the *Report of the Officers Constituting the Lighthouse Board:*

Bay light: serving also for York River. Isaac Foster, principal and only keeper; retired sea-captain; (has five sons at sea). Appointed January 1847; has a negro woman of his own to assist him in keeping the light. Salary $400, and no allowance for an assistant; desires an allowance for wood; is on an island. Tower of sandstone; ashlar outside, rubble inside; whitewashed inside and out; present condition good; leaks a little above, but stopped with putty; loose stone about foundation. Lantern six feet in the clear; fixed light; lamps, burners, and tube-glasses, as usual, common. Reflectors scratched; want silvering as well as cleaning; two extra lamps, which keeper thinks not enough, as they give out and are not always well repaired; tube-glasses indifferent. Tower too low from last floor to platform; fifty feet from platform to sill of door; glass 24 x 16 inches. Interior of dome painted white; no curtains. Ventilators as usual; trap-door closed; moderately clean. Tower painted and whitewashed; reported in good condition; wants locks and catches; oil in cellar of house. Dwelling is a frame-house, painted white. Oil does not freeze in cellar, but gets thick in winter. Foundation of building good. Received supplies once a year. Lights up at dark and puts out at daylight; turned down in putting out; keeper thinks there is no use in lighting at sunset! Trims at 11 or 12 in summer; in winter at 10 and 2 o'clock. No watch kept, but always wakes at the right time. Has the usual printed instructions; keeper says the light is not considered bad in the Bay; keeper thinks curtains of no use! there are none.

The lighthouse was attacked by Confederate guerrillas during the Civil War and put out of commission for awhile; it was repaired and relighted in 1865. The light was converted to automatic acetylene gas operation in 1919. In 1930 an official report to the Bureau of Lighthouses mentioned that "the usefulness of the property has not diminished. Appears to be no likelihood of it doing so soon." Nevertheless, it was discontinued and abandoned in the early 1950s, made obsolete by a tiny lighted buoy.

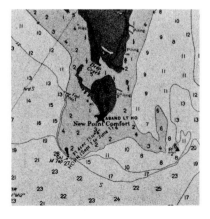

Looking down at the stones around the
base of the tower.

Sandstone at the base of the tower,
eroded by wind and water.

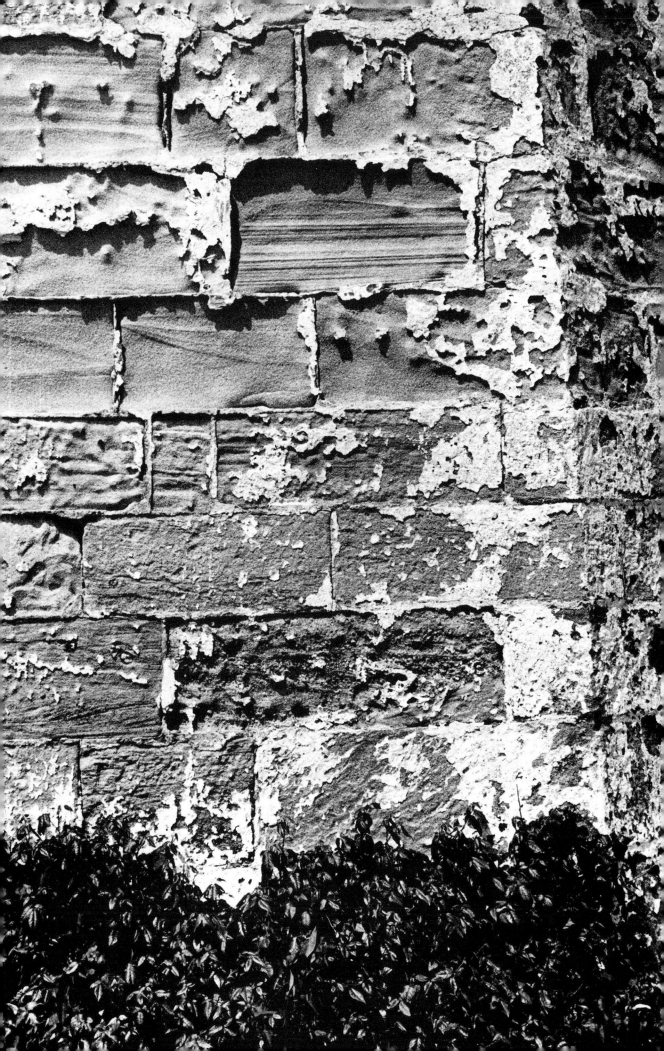

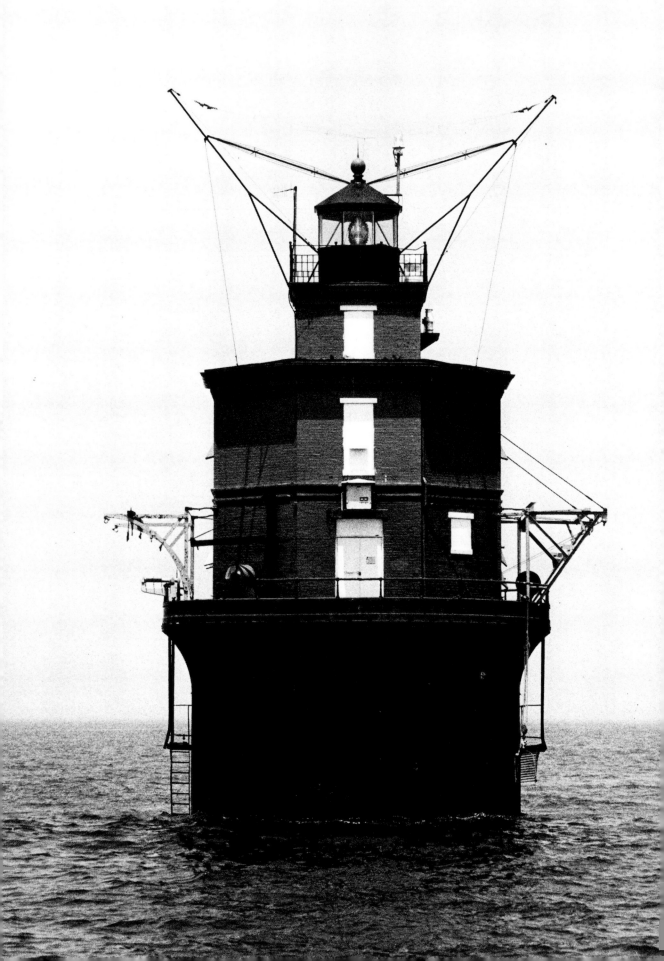

Wolf Trap

The stranding of *H.M.S. Wolfe* in 1691 gave the shoal its name. The *Wolfe*, a 350-ton merchantman, had been hired by the Royal Navy to act as part of a convoy and to help with the suppression of piracy and smuggling in the New World's waters. She left England in December, 1690, and arrived off Cape Henry on March 16, 1691, after an uneventful but lengthy crossing. The next day, however, her captain, George Purvis, ran aground on the unmarked shoal further up the Bay, and remained there for almost three months. Watermen from nearby Middlesex and Gloucester counties helped float the vessel after the heavy guns and ammunitions had been taken off. Although Captain Purvis admitted that without them the ship "would have been utterly lost," he balked at paying the salvors the 23 shillings a month which the Council of Colonial Virginia considered fair. He would pay only 18 shillings per month. The watermen were not paid for two years, and then only after garnishee proceedings had been threatened.

A few years later, when John Thornton's *New Map of Virginia* was published, the shoal was first indicated by name as "Wolfe's Trap." In 1821 a 180-ton lightship was placed on the shoal; it was destroyed by Confederate raiders in 1861. On October 1, 1870, a hexagonal screwpile lighthouse was put in operation. It was destroyed by moving ice on the night of January 22, 1893. The following day the revenue cutter *Morrill* discovered the lighthouse floating within one mile of Thimble Shoal, 20 miles to the south, drifting toward the Capes. The keepers had managed to reach the mainland. Only the top of the lantern could still be seen, and the wreck was an obvious hazard to navigation. The cutter made fast a hawser around the lantern, towed the wreck toward shore, and allowed it to drift onto the beach.

The Lighthouse Board tender *Holly* served temporarily as a lightship until a relief lightship could arrive on station. It served until September 20, 1894, when a new caisson-foundation light tower was completed, a "brown cylindrical foundation pier expanding in trumpet shape at its upper end to form a gallery." A fog signal was placed on top of the octagonal red brick keeper's quarters. The lighthouse was automated in 1971 and still flashes an 18,000-candlepower white light every 15 seconds from its 52-foot tower.

Early morning, looking toward the
Eastern Shore.

Decorative metal finial topping the privy.

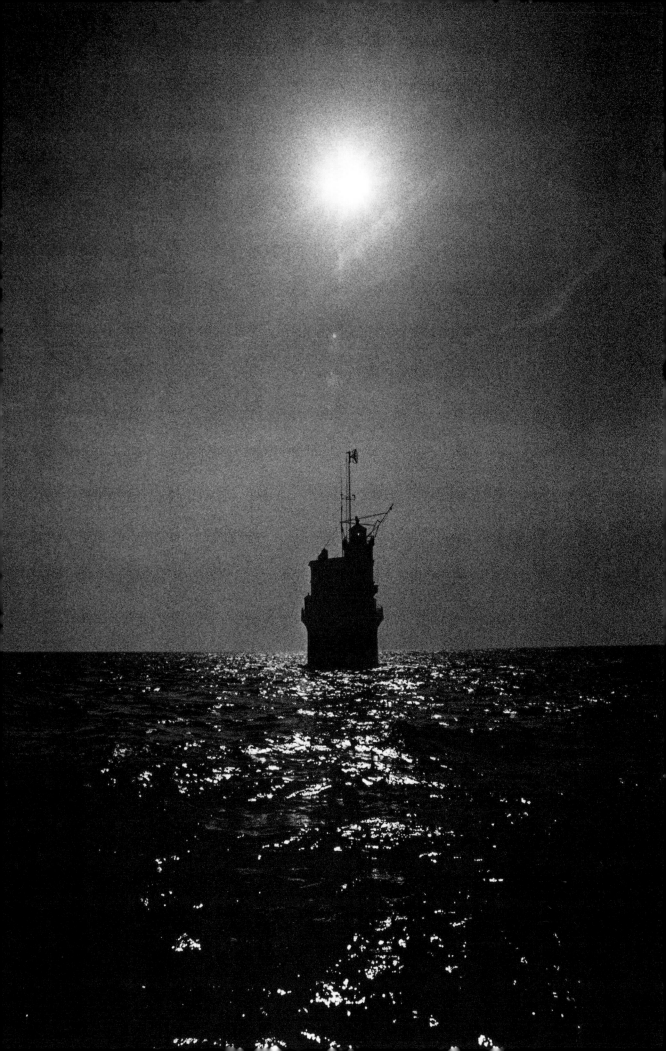

Smith Point

Smith Point lighthouse, at the often turbulent mouth of the Potomac River, was built in 1802. Thomas Jefferson appointed William Helms as keeper at an annual salary of $250. The light was built too close to the water's edge, and in 1807 it was rebuilt further inland at a cost of $6,000. By 1828 it had to be rebuilt again. Winslow Lewis made the successful bid of $5,440. He built a new tower 90 yards further inland, after a few more acres were purchased for $500.

A quarter of a century later, Lieutenant A. M. Pennock, an officer of the Lighthouse Board, reported in the 1853 annual report: "I beg leave to call the attention of the board to the dilapidated condition of Smith's point light-house. The entire illuminating apparatus requires renewing. The iron frame which supports the lamps is so weak that no great effort would be required to shake it down. The tower is badly cracked, and not more than 35' from the edge of the bank, which is fast giving way. To put this establishment in order the cost would be great." He recommended that a first-class screwpile lighthouse be built near the end of the spit making off from Smith Point.

A lightship had been stationed three miles from the lighthouse since 1821 to provide additional guidance for ships and constituted a tacit admission of the ineffectiveness of the light on the mainland. The ship was destroyed by Confederate guerrillas in 1861, but the following year a 203-ton brig was purchased and outfitted for use as the Smith Point lightship (the mainland light was discontinued in 1859). Congress finally appropriated the funds suggested by Lieutenant Pennock, and on September 9, 1868, a new screwpile lighthouse was finished and the lightship decommissioned.

In 1893 the new lighthouse was severely damaged by ice, and the terrified keepers abandoned their station, for which they were summarily dismissed. A more damaging onslaught of ice, on February 14, 1895, severed the house from its foundation and carried the superstructure away. Once more a lightship was placed on station until a new lighthouse could be constructed. The third lighthouse at Smith Point was finished in 1897 and is still standing. It is a square brick tower 52 feet high on a cast-iron caisson base with a two-story octagonal dwelling for the keeper. The light was automated in 1971, but its 200,000-candlepower beam continues to warn the thousands of ships that pass Smith Point every year.

Brick chimney on roof of the keeper's
quarters, now capped off.

Staircase in the tower, identical to the
one at Wolf Trap.

44

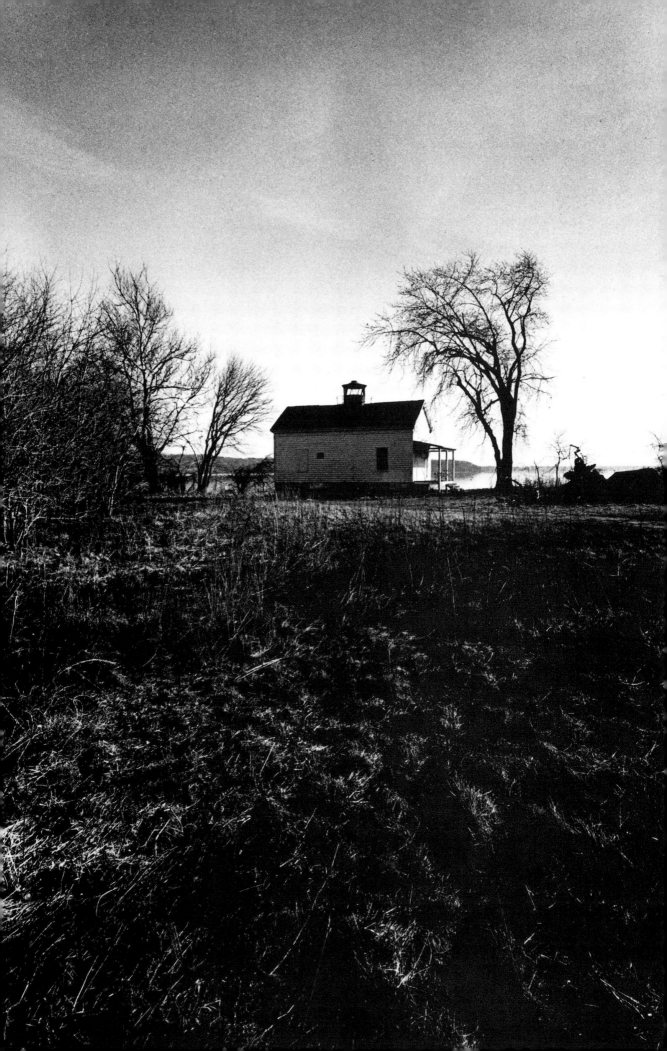

The tiny lighthouse on Jones Point, a half dozen miles from the United States Capitol, was built in 1855 and first lighted in May, 1856. It is the oldest standing inland lighthouse in the United States. The point is located in Alexandria, on the western shore of the Potomac River; on it is the original stone used by the surveyors in 1791 to mark the southern boundary of the 10-mile-square District of Columbia.

In 1854 an area of 3,000 square feet was purchased by the federal government from the Manassas Gap Railroad Company to provide a site for the construction of a lighthouse. Because of its small size, easy access, and proximity to suppliers, it turned out to be one of the least expensive to build of all lights on the Bay or its tributaries. It is believed that this lighthouse was the first in the United States to use gas as fuel for its light. Sometime in the 1860s pipes were laid from the Alexandria Gas Works to the station, but the pipes leaked and water often blocked the passage of the gas. On November 20, 1900, the light was converted again to oil operation, and the light's color characteristic changed from white to red. Gas was never entirely satisfactory as a fuel for lighthouses and was not extensively used in the United States.

The importance of Alexandria, Georgetown, and Washington as ports began to wane in the early part of this century. The Lighthouse Bureau annual report for 1923 charged that "the Jones Point lighthouse is of little use on account of changes in shoreline at this point. It is recommended that Jones Point be discontinued after the installation of several buoys."

The river had shoaled so much near the point that the lighthouse was discontinued in 1926. The buoys were never placed; instead, a 60-foot steel tower with a flashing red light on top was built 100 yards from the lighthouse. It was torn down in the late 1930s.

Because of its historical significance, the Lighthouse Bureau gave the building to the Mount Vernon Chapter of the Daughters of the American Revolution, but lack of funds prevented restoration and maintenance, and the building fell into disrepair. During World War II, the land at Jones Point was used by various defense agencies. The United States Army built a communications relay center and also used the property for a canine depot. After the war the Coast Guard operated a radio station there. The United States Navy acquired the site in 1955 and now uses the point as a Naval Reserve Center. In 1966 the abandoned lighthouse and several acres of the surrounding area were transferred to the National Park Service, which eventually hopes to restore the lighthouse (their current estimate of the cost is $100,000) and make Jones Point into a park.

Looking down the Potomac toward
Fort Washington.

Reconstructed porch on the west side of
the lighthouse.

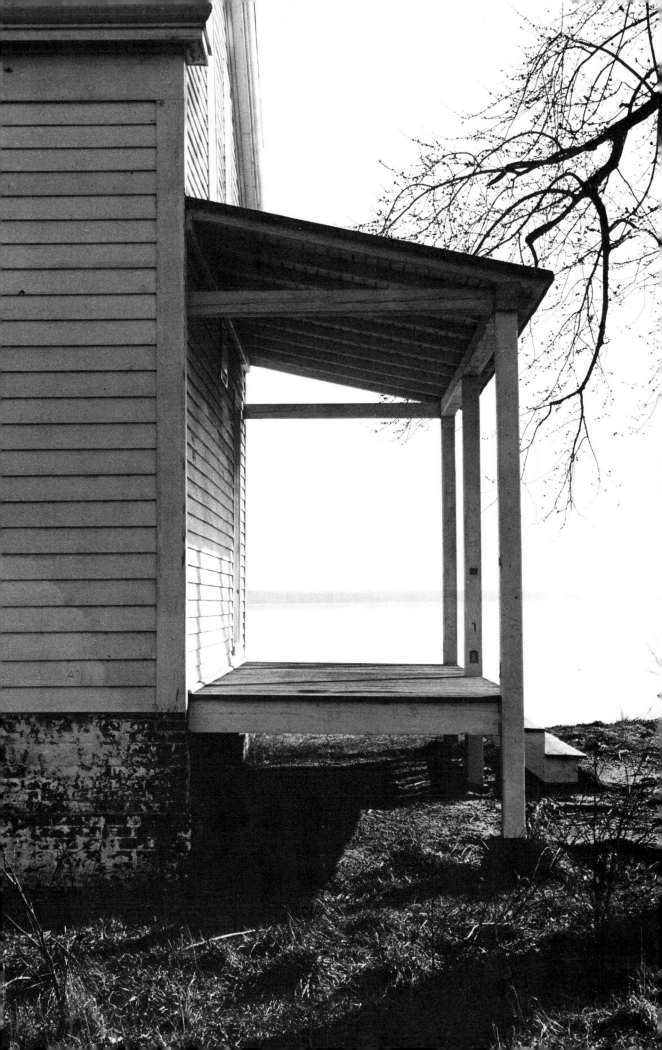

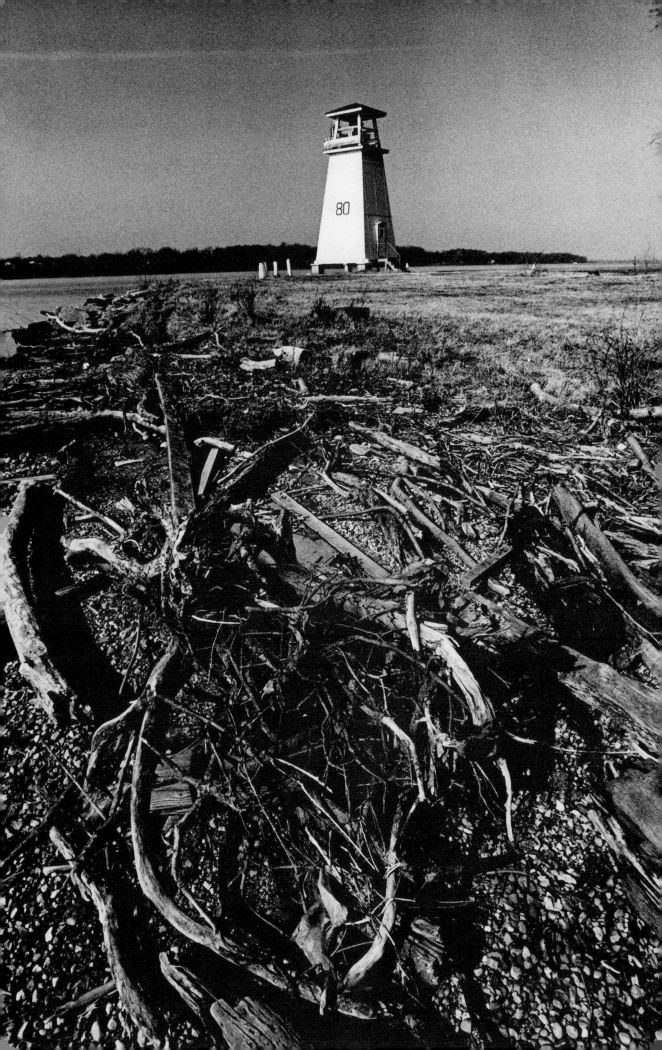

Fort Washington

"Should proper works be erected here," wrote George Washington to the secretary of the navy in 1798 of the fort which was later to bear his name, "it would not be in the power of all the navies of Europe to pass that place." Nevertheless, on August 27, 1814, five years after it was built, the British did pass the fort, then called Warburton. The fort is 16 miles southeast of Washington, and its commanding officer, Captain S. T. Dyson, destroyed it rather than have it fall into the hands of the British, who sailed up the Potomac to Alexandria a few days after their land forces had captured Washington. It was rebuilt in the next decade, first under the direction of Pierre L'Enfant, and later under Colonel Walker K. Armistead. It was essentially completed in 1824 and has been little altered since.

In 1856 the secretary of the Treasury, James Guthry, wrote to the Lighthouse Board: "I enclose herewith a letter from the Secretary of War . . . granting permission to erect a small light at or near the landing at Fort Washington, on the Government land, on condition that the light shall be placed on the wharf, and not within any of the fortifications, and that the keeper shall be subordinate to the military command of the post and public ground, in all that relates to police and discipline." The following year a cast-iron column 18.5 feet high with a small light on top was erected at the wharf under the fort.

Complaints about the inadequacy of the light were soon made, and in 1870 a small tower was built and a sixth-order Fresnel lens installed. This was really the first "lighthouse" at Fort Washington.

The building of several sheds and boathouses on the wharf eventually obstructed the light, and it was decided to use the fog bell tower, which stood closer toward the river, as the base for a new one. Even so, the bell tower had to be raised several feet for the light to be seen from up- or downriver. The old lighthouse tower was torn down in 1901. The keeper's house, which was built in 1884 after 25 years of requests, was also torn down after the light was automated. So the 32-foot fog bell tower became a lighthouse tower, and the fog bell, which sounds continuously from the middle of August through the middle of May, now shares the small space available with the Fresnel lens.

The fort itself was abandoned in 1872 but reactivated in 1896, when it became headquarters for the Defenses of the Potomac. In 1921 it became the home of the 12th Infantry and in 1939 was transferred to the Department of the Interior. Since 1946 it has been administered by the National Park Service and is open to the public year round.

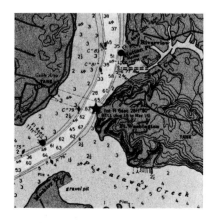

Looking south toward Piscataway Creek.

Mortise and tenon cross-bracing inside the tower.

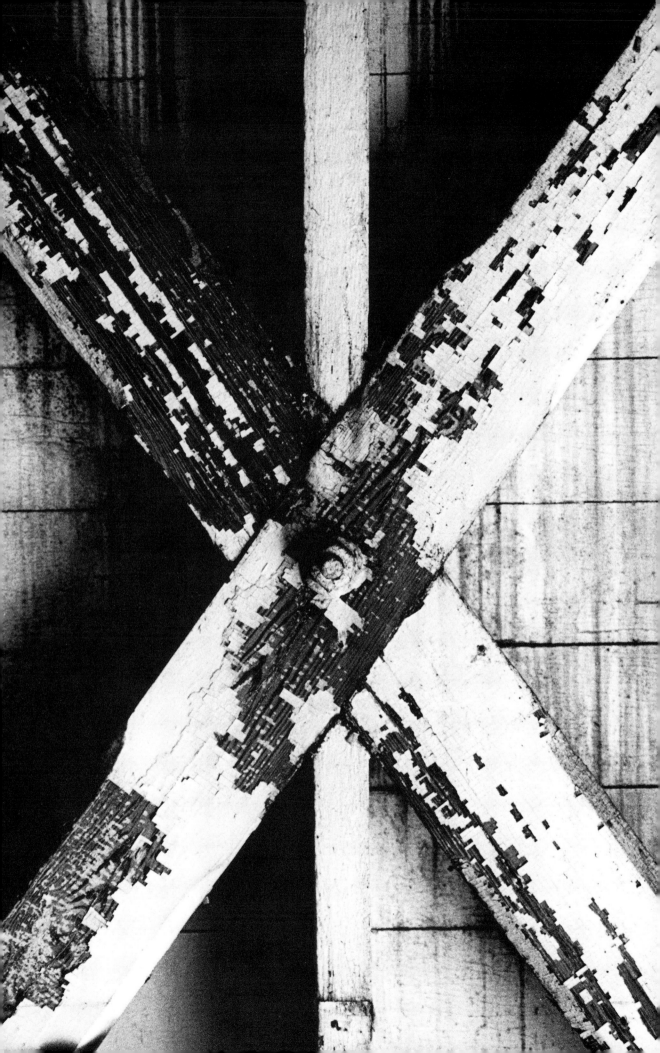

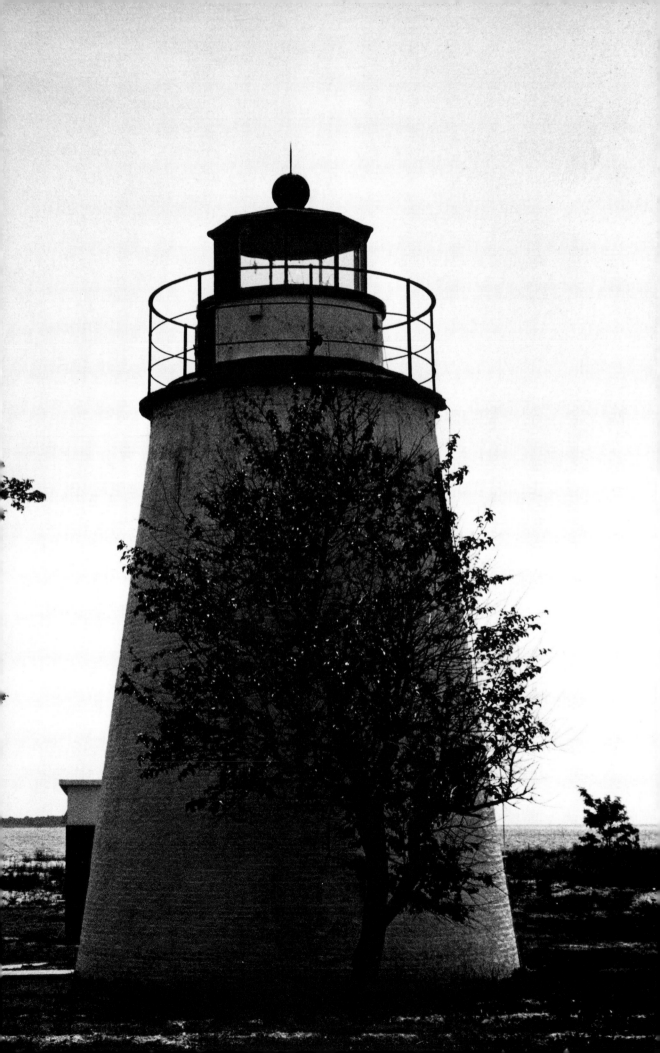

Piney Point

Piney Point was the first lighthouse built on the Potomac River, although there had been a number of lightships on the river since 1821. Located on the Maryland side, 14 miles from the mouth of the Potomac, the 35-foot tower was built in 1836 for almost $5,000 by the ubiquitous John Donohoo, who for several decades had a virtual monopoly on lighthouse construction around the Bay. The lighthouse is no longer in use, although the Coast Guard still maintains a station at Piney Point.

During a recent interview, Marion Humphries, whose father was the keeper at Piney Point early in this century, reminisced about his childhood (he was seven years old when his father was transferred to the point in 1907):

You ever see Piney Point? God, how I loved that place when I was a kid. I didn't have to go to school, cause there wasn't any! There was no schools anywhere near Piney Point! My mother was my teacher. We lived there until 1912.

I loved to help my dad with the light. I knew every part of the machinery that operated that light and the fog signal. I knew what it was supposed to do and knew how to handle it as good as my dad. I helped him out. Of course he was there to supervise. He was a stickler. I never made any mistakes though, for he wouldn't stand for it. There was no room for mistakes. No mistakes of any kind. It could not be. It was beat into your head that what you were doing was for the protection of the lives of people.

And the inspectors were the toughest people that God ever put on this earth. I remember one inspector, it was about 1908. He was a retired naval officer by the name of J. K. L. Ross; he worked out of Fort Washington. I'll never forget that man. As soon as he got inside the door, he pulled a pair of white gloves out of his pocket, put them on, and he would run his fingers all along the door's top facing to see if there was any dust on it. One time he told my dad: "I'd like to congratulate you. Your place looks like a man o'war." Made the old man pretty proud.

Looking north toward Piney Point Creek.

Combination ventilator cap and lightning rod on top of the lantern.

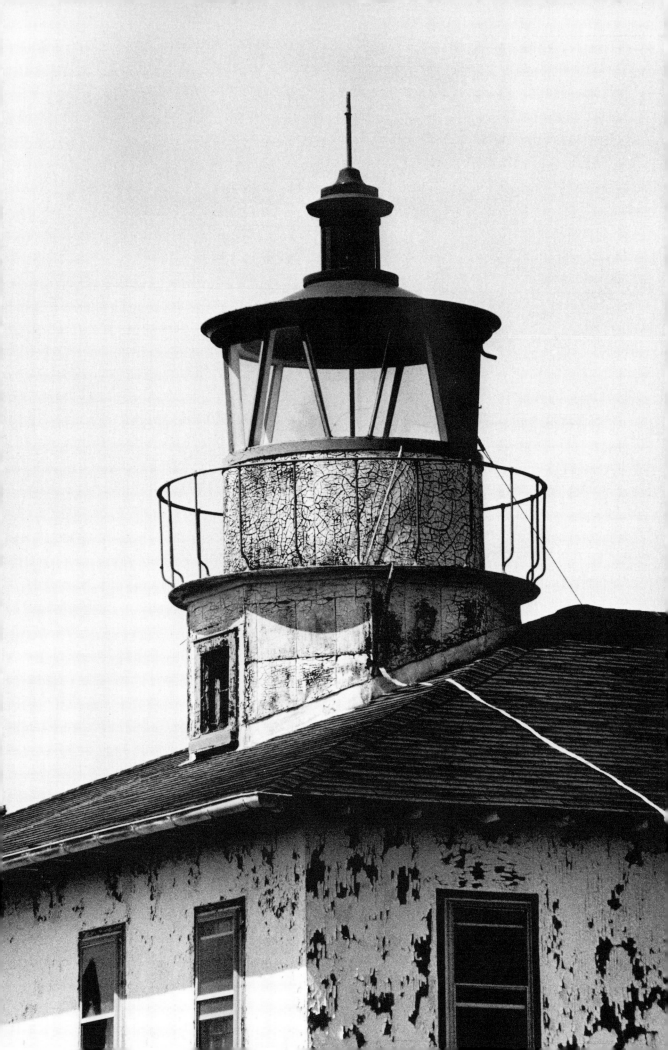

Point Lookout

Point Lookout and
Point Lookin;
Point No Point and
Point Again.

So goes an old sailor's ditty. Point Again doesn't exist, at least not in Maryland, but Point No Point and Point Lookin are within a few miles of Point Lookout, which is at the northern entrance to the Potomac River. The lighthouse at Point Lookout, built for $3,350 in 1830 by John Donohoo, is a small house with the lantern on top of its roof. At first the light was 24 feet above the ground, but the house and the lantern were later raised to 41 feet.

Like Turkey Point light, near the head of the Bay, Point Lookout had its share of female lighthouse keepers. One of them, Ann Davis, was complimented in a report made in 1840 by the captain of the lighthouse service supply boat. "Mrs. Davis is a fine woman," he wrote, "and I am sorry she has to live on a small naked point of land."

The light was discontinued in 1966 and the house and property surrounding it turned over to the United States Navy, which leases it to the State of Maryland. The superintendent of Point Lookout State Park now lives in the lighthouse, and the state Parks Department hopes to acquire the property, restore it, and eventually open the lighthouse to the public.

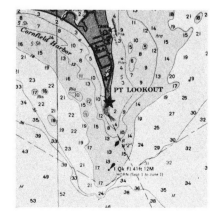

Gulls gathering on the sandspit at the
entrance to the Potomac.

Blistered paint on the gallery door,
almost hiding the arrow-shaped strap
hinge at upper right.

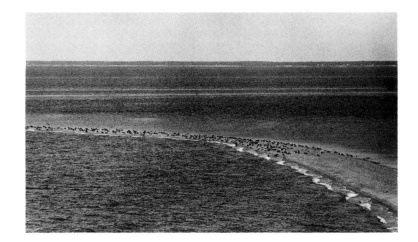

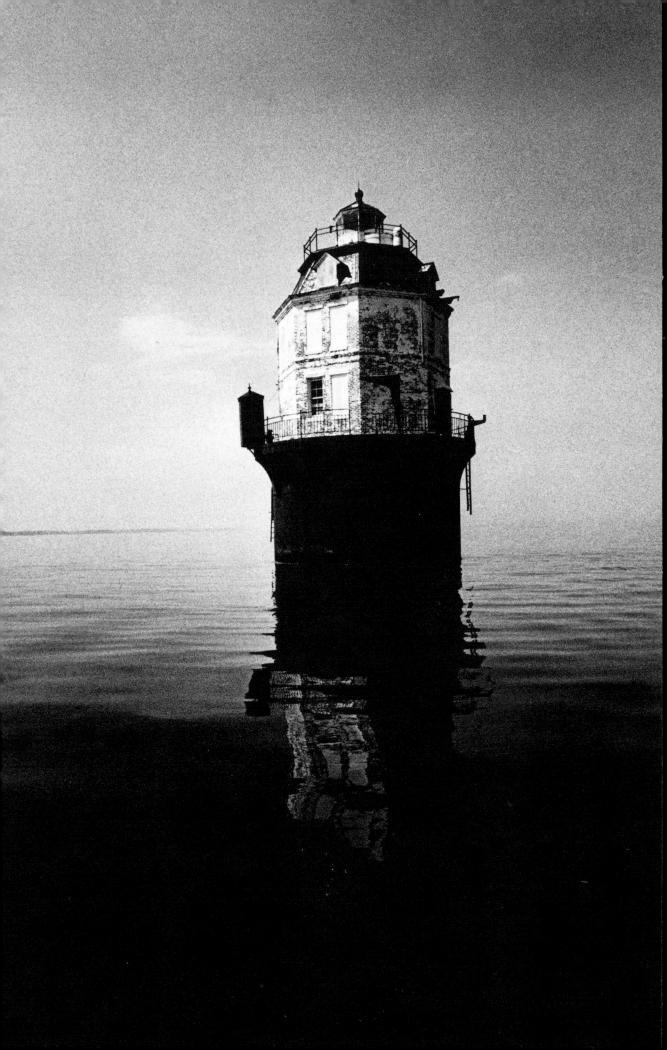

Point No Point

Six miles north of Point Lookout and two miles from shore on the western side of the Chesapeake stands Point No Point lighthouse, one of four lights built in the Bay in the twentieth century.

The first request to erect a lighthouse here came in 1891. As the Lighthouse Board reasoned: "There is a stretch of about thirty miles between the Cove Point and Smith Point lights which should be better lighted. For a part of the distance navigators are without a guide, where a deviation from their sailing course might carry vessels of heavy draught on to dangerous shoals. There are many of this class of craft now trading to Baltimore, and their number is increasing. A light-house on the shoal of Point No Point would be useful warning." The estimated cost was $35,000.

The request was repeated in the next two years, to no avail, and by 1894 the price had gone up: "In view of recent damages by ice to screwpile structures in Chesapeake Bay, the Board is now of opinion that only caisson structures should be used where such dangers exist, and that a caisson structure should be erected at this place. It is estimated that it may cost, in view of the possibly soft bottom, not to exceed $70,000." Finally, in 1901, $65,000 was appropriated, bids sent out, and contracts awarded. In August, 1902, work was started on the fabrication of the caisson, which was towed to the site the next April.

Soon after, a temporary pier built by the contractors during the previous summer gave way, and the caisson, which was tied to the pier, turned over. After some of the cast-iron plates broke off, it drifted down the Bay before a northwest gale. The contractor's tug followed and picked up the caisson the following day off the mouth of the Rappahannock, 40 miles to the south. It was towed back to Solomons Island for repairs. On October 22, 1903, it was floated into position and sunk in place. A year and a half later, on April 24, 1905, the light was first shown from the finished tower by the first keeper, Anders Simonsen.

The lighthouse is an octagonal two-story brick building, 52 feet high, with a mansard roof, which sits atop a cast-iron cylinder 30 feet in diameter. The lighthouse shows a flashing white light every six seconds. The light was converted to automatic operation in April, 1962.

Looking toward St. Mary's County at sunset.

Barnacles encrusting the caisson foundation at the waterline.

64

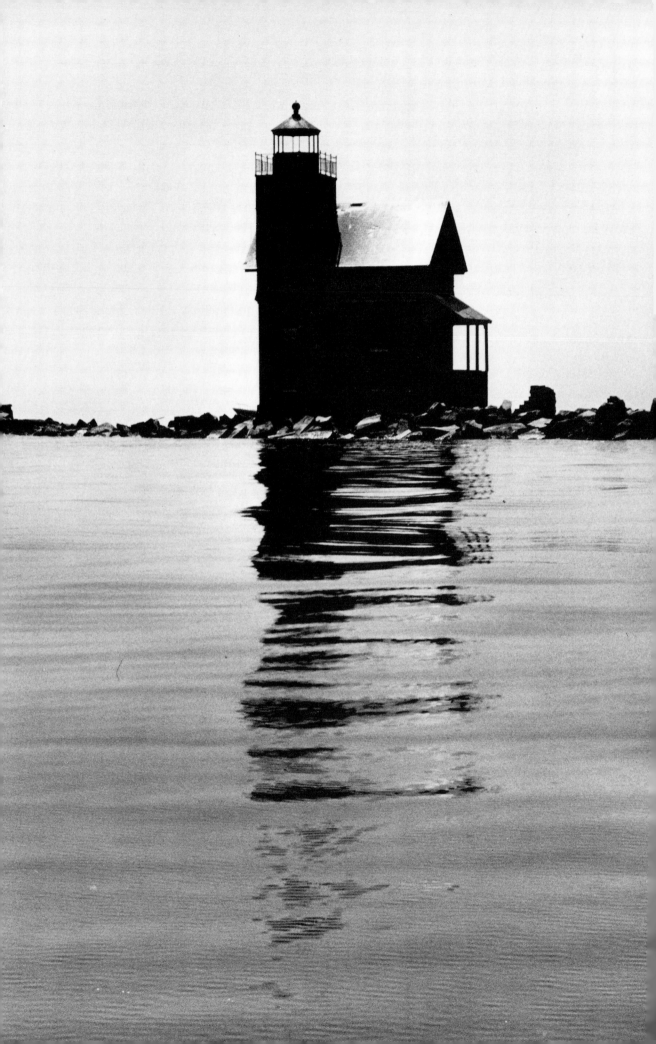

Cedar Point

Cedar Point lighthouse lies in ruins at the edge of the Patuxent Naval Air Station, near the southern entrance to the Patuxent River. Although now surrounded by water, it was built on land. In 1894 an acre and a half was purchased to provide the site, and $25,000 was appropriated for its construction. The Lighthouse Board annual report for 1896 tells of the progress:

Contracts were made for furnishing the metal work and for erecting the lighthouse. The metal work was finished and delivered at the Lazaretto lighthouse depot. On May 7 the erection was begun. By the end of June the concrete foundations of the dwelling and light-tower were finished and the frame partly erected. The foundation for the oil house was laid and the rafters were fitted together. The boat house and fog bell tower were nearly completed, and the brick foundation of the outhouse was laid and the frame was made ready for erection. The date fixed by the contract for the completion of the work is September, 1896, and the station is to be ready for use by that time.

The lighthouse was built in cottage style, of wood and brick. It had a square white tower which rose from a corner of the roof. A small 15-foot wooden bell tower was located a few yards away. It originally had a fourth-order Fresnel lens.

Land erosion was and is a severe problem at Cedar Point. Nearby dredging for gravel and sand made the problem worse, and eventually a peninsula was created around the light. By the early 1920s it was totally surrounded by water, and the decision was made to abandon the light and install an automatic post beacon nearby. The entire acreage (except for a 100-square-foot parcel just large enough to accommodate the post light) and the lighthouse were sold to the Arundel Corporation for $2,100. The post light was abandoned in 1956, and now only a small lighted bell buoy nearby serves the mariner.

Pattern made on the water by wind and current.

Brick and granite steps, torn away to prevent entry to the lighthouse.

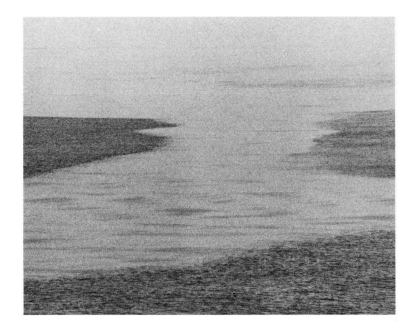

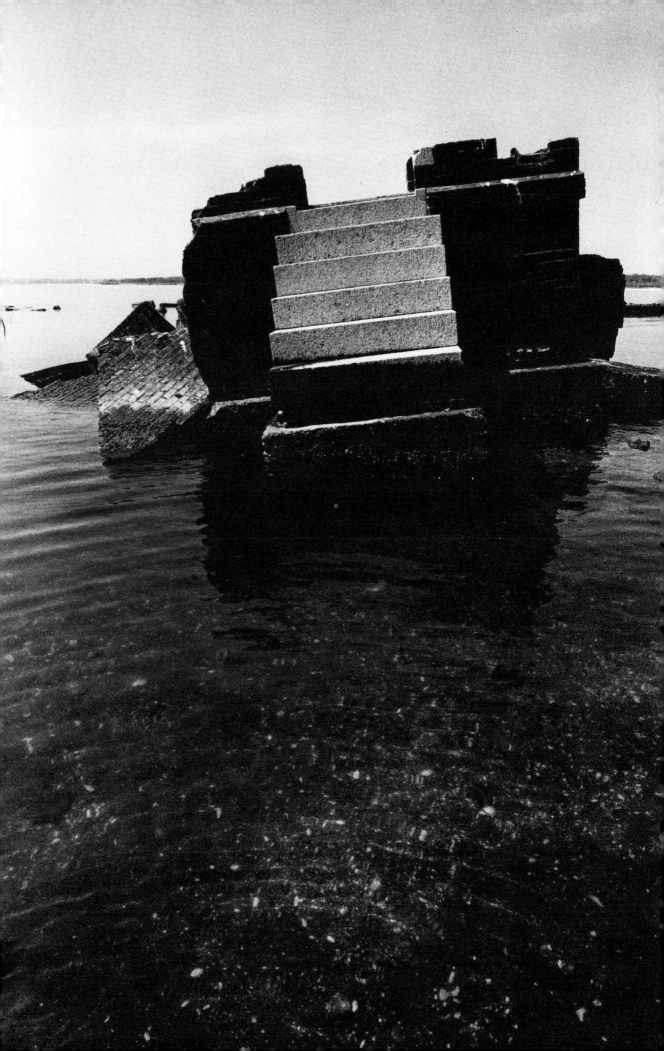

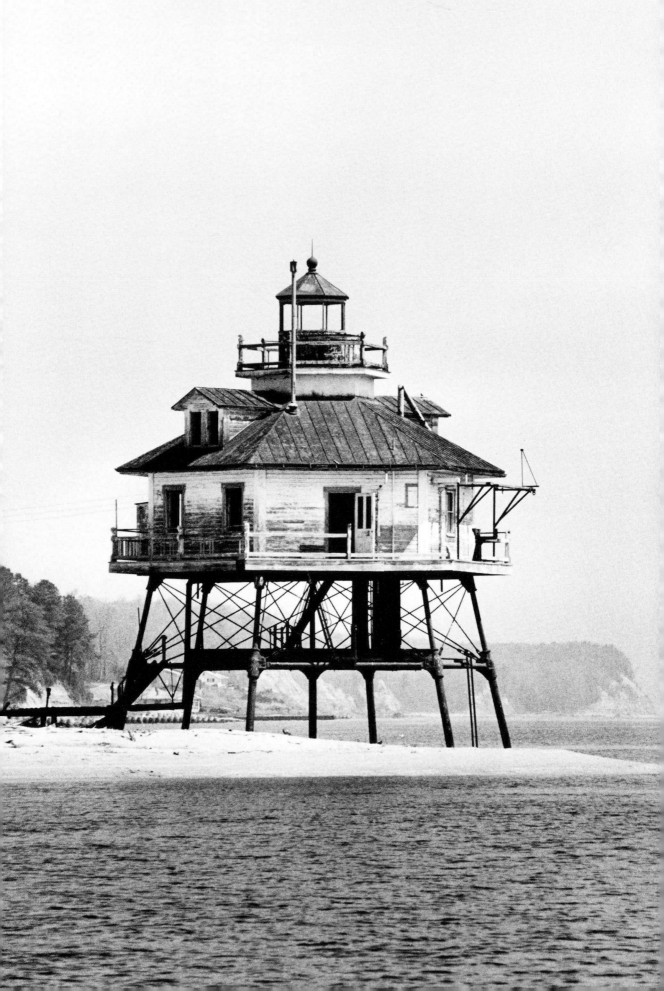

Drum Point

Drum Point lighthouse is one of the few screwpile lights still remaining on the Chesapeake. It stands at the entrance to the Patuxent River near Solomons Island. When first constructed in 1883 it stood offshore in about 10 feet of water, but over the years extensive shoaling occurred and today it sits high and dry at low water.

The lighthouse was first proposed more than 30 years before it was built. Lieutenant A. M. Pennock, a member of the Lighthouse Board, recommended in 1853 that a small light be placed on Drum Point because vessels of all classes took advantage of this lee and in thick weather several had gone aground on the spit making off from this point. In 1882 an appropriation was made for two range lights, but the amount allocated was so small that the Board decided to build only one. The hexagonal lighthouse, which is built on seven 10-inch wrought-iron piles, cost $5,000. It showed a fixed red light through a fourth-order lens when first commissioned on August 20, 1883. As most of the building components had been prefabricated and the location was in relatively sheltered shallow water, construction took only 33 days.

It was discontinued in 1962 and deeded to the State of Maryland, which hoped to restore it, but access to the light by land is only possible through private property, so the state returned the lighthouse to the General Services Administration. The Calvert County Historical Society hopes, with the aid of state funds which have already been appropriated, to move the lighthouse several miles to Solomons Island, where, after restoration, it will be opened to the public.

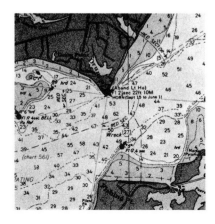

Looking almost straight down from the
balcony to the sandy beach below.

One screwpile, with Patuxent River and
Naval Air Station beyond.

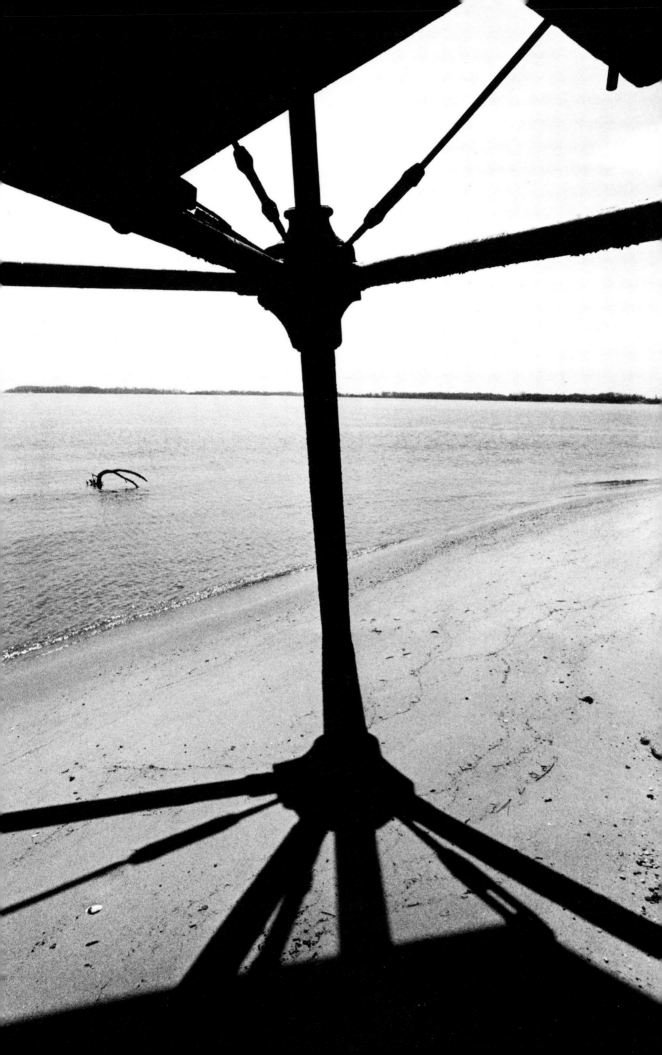

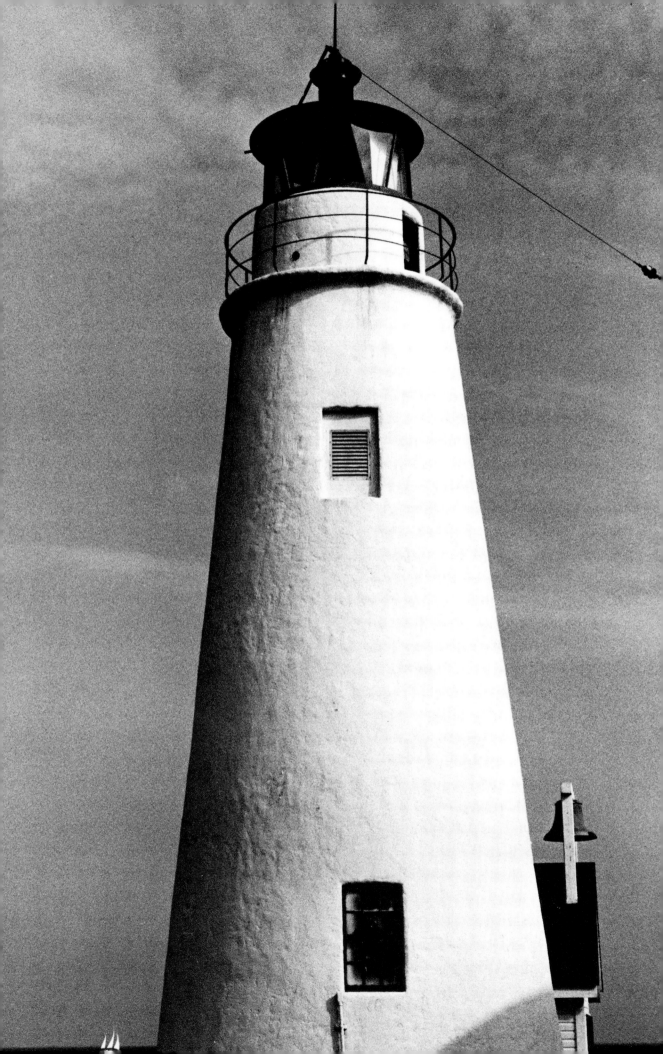

Cove
Point

Cove Point lighthouse was built in 1828 by John Donohoo of Havre de Grace, who constructed most of the early lights on the Chesapeake. Four acres of land were purchased for $300, and a 38-foot tower (it was later raised to 51 feet) was built of brick for $5,685. Eleven lamps with 18-inch reflectors were installed. The first keeper at Cove Point, James Somerville, was selected from a group of seven applicants. The keeper's dwelling, a 34- by 20- foot stone house, was based on the design used for the houses for the keepers at Thomas Point, Bodkin Island, North Point, Pooles Island, Havre de Grace, and Fog Point. As early as 1842 there were reports of rapid shore erosion, and retaining walls were built to protect the lighthouse. Today the water is within a few feet of the tower, and it continues to be in danger of being undermined.

Cove Point still has resident personnel; three Coast Guardsmen and their families live on the two-acre property and maintain the light, fog signal, and radio beacon. The light is turned on half an hour before sunset and turned off half an hour after sunrise. The switch is located in the foot of the tower so that the keepers do not have to climb the steps except to clean the lens occasionally (it is still the original fourth-order Fresnel).

The three keepers take turns at the job. Their duty schedule calls for shifts of 8 hours on and 8 hours off for 48 hours, followed by 24 hours off. Every third weekend they are free to leave the station. Every three hours the keeper on duty calls in the weather conditions to Coast Guard headquarters, from which it is relayed to the National Weather· Service in Washington. The light flashes a 150,000 candlepower beam every 10 seconds. The *Light List* notes that the beam is obscured from 040° to 110°, which seems strange, for there are no high buildings or trees around the tower. The explanation is unexpected: years ago a woman living in a house several hundred yards from the lighthouse complained that every 10 seconds the bright beam flashed by her bedroom window. The Coast Guard, in a marvelous and courtly gesture, ordered a curtain hung in the tower at such an angle that she might be spared the blinding flash and assured of restful nights.

Cove Point sandspit at high tide.

The cast-iron treads nest on top of each
other in the stairwell.

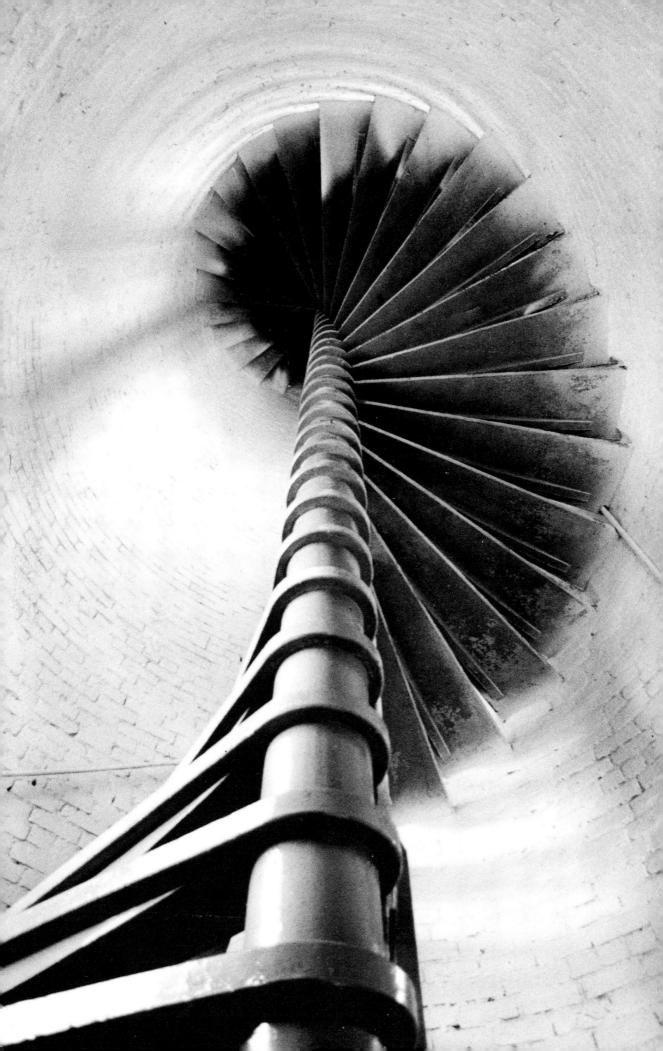

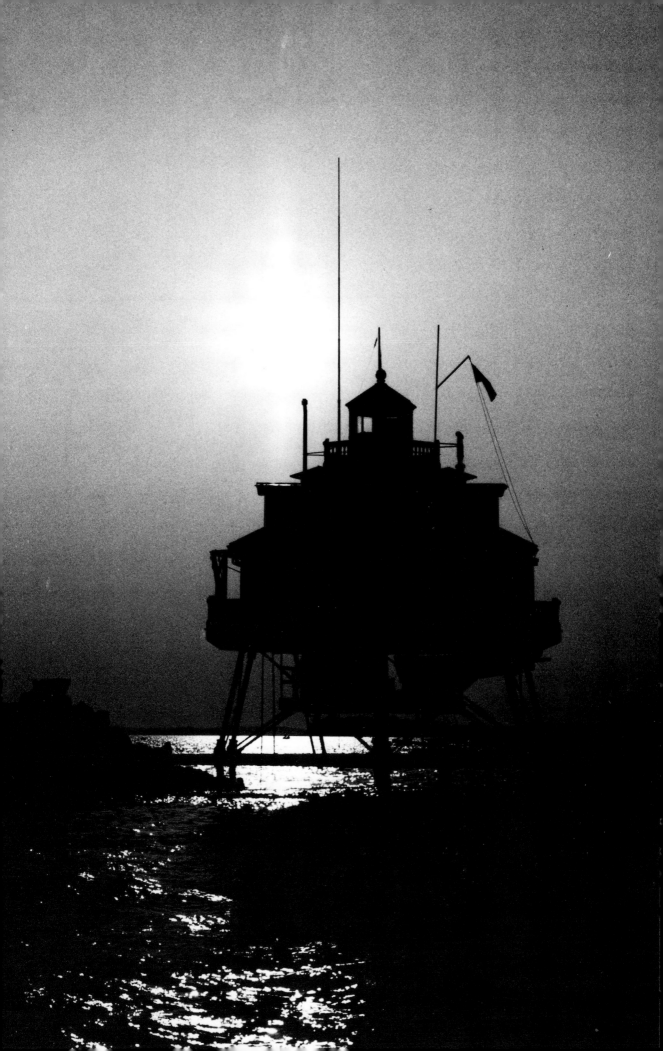

In 1824 a seven-acre parcel of land on Thomas Point, part of Davidge's Purchase, was sold to the government by Jeremiah T. Chase for $529.69 in "current money." In the following year the first lighthouse was built on this point near the entrance to South River by John Donohoo. It was Donohoo's first lighthouse construction experience; he went on to build a half dozen others on the Chesapeake Bay. The lighthouse on Thomas Point ended up costing $5,676, but Donohoo's inexperience became apparent several years later when the poorly constructed tower had to be rebuilt. In 1838, Winslow Lewis got the contract to tear the old tower down and built a new one. He used a lot of the old materials and charged only $2,500.

The Lighthouse Board complained in its 1872 annual report that "its present location is such that little use can be made of it at night, and in times of thick or foggy weather it is utterly useless." The shoal off Thomas Point had become larger and forced vessels of deeper draft farther away from land. The Board for some years considered erecting a caisson-type lighthouse at the end of the shoal but because of the great cost decided in favor of a much less expensive screwpile structure. On November 20, 1875, the small hexagonal house was commissioned, and the old structure on the point was discontinued. Winslow Lewis' tower finally fell down on February 28, 1894. It had been briefly re-activated in 1877, when vibrations from ice floes piled up in the Bay overturned the lens in the new lighthouse, and a temporary light was displayed in the tower. In 1886 more than 1,400 cubic yards of riprap stone were placed around the building to protect it against ice.

The land on the point was sold in 1914 to private interests for $426, $100 less than the original purchase price. Thomas Point Shoal light is the last manned screwpile lighthouse on the Chesapeake. After almost 100 years in service it is in excellent condition, but the Coast Guard plans to automate the light and foghorn apparatus in the next few years and to relocate the Radio Direction Calibration Service, which has been the main reason for keeping resident personnel at the station.

Standing-seam metal roofs and pitched
roof dormers, showing the many-leveled
living quarters.

The fourth-order Fresnel lens at night.

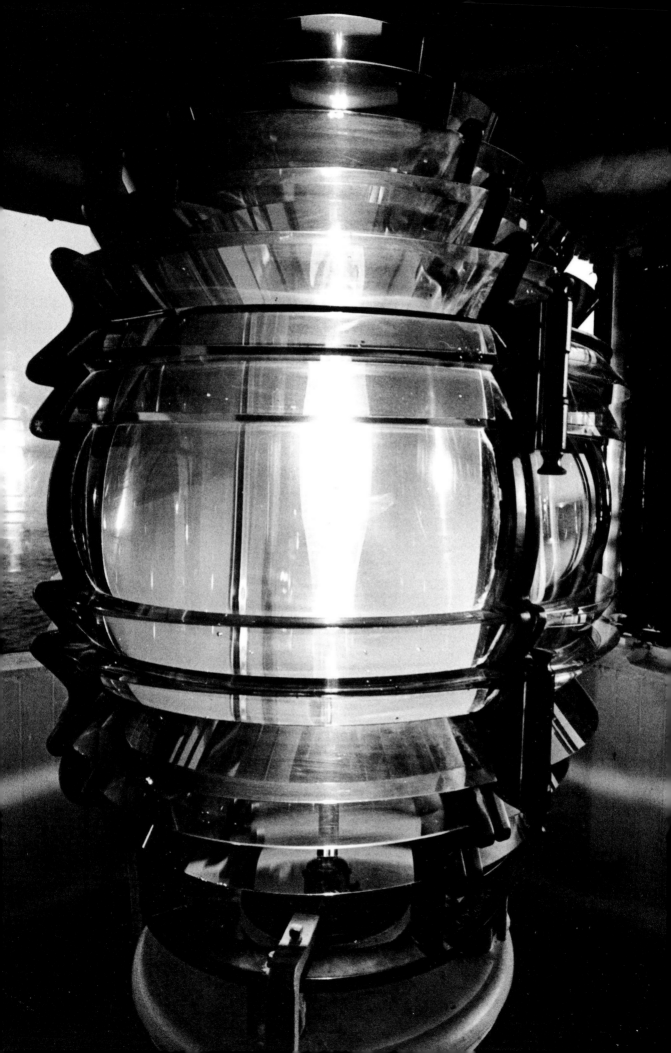

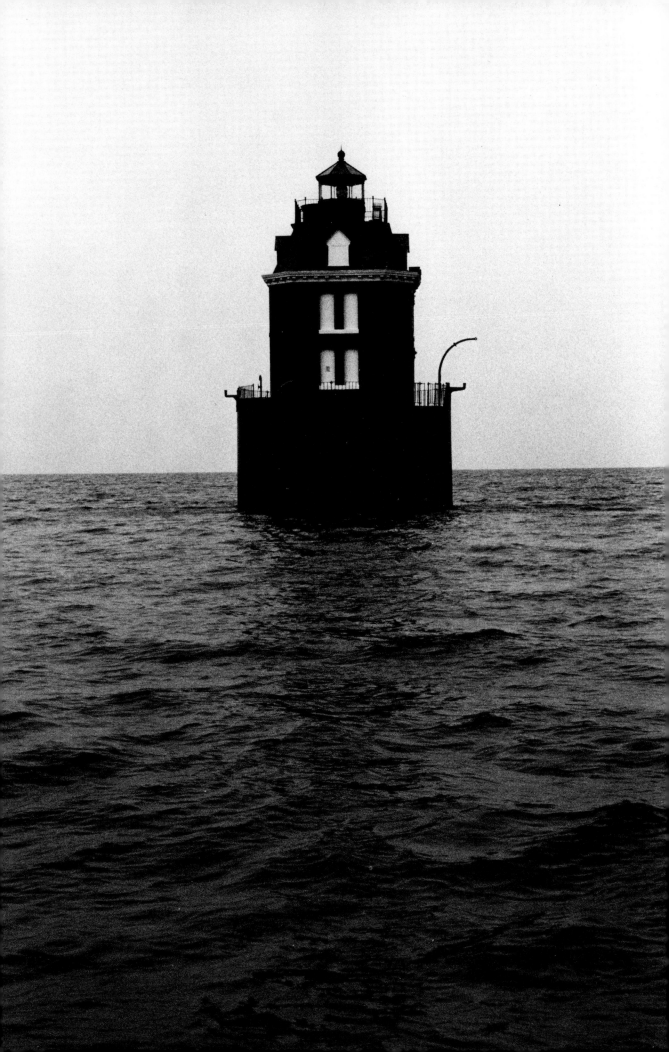

Sandy Point Shoal

Like Smith Point and Thomas Point, both initially built on land, the first Sandy Point lighthouse was erected on shore, on the western side of the Bay, near the present site of the Chesapeake Bay Bridge. Work was started in 1857, and the lighthouse was completed the following year. The lighthouse and the keeper's dwelling were one and the same, for the tiny lantern was placed on the roof of the house.

In 1863 a fog bell was installed, but a decade later both the light and the bell were becoming useless. The Lighthouse Board 1874 report describes the problem:

Sandy Point light is located on the main-land, from which place continuous shoals make out into the bay, a distance of about one mile, and vessels drawing more than ten feet of water cannot approach within that distance of the light-house. A fog bell is established at this station, but, on account of its distance from the channel, can seldom be heard. The defects of its location are especially felt during stormy weather in winter. Nearly all the passenger-steamers running into the port of Baltimore from below, of which there are many, change their course at this point, and this becomes a hazardous undertaking to boats crowded with passengers and running on time, when neither the light can be seen nor the fog bell heard. A change in the location of the light to the outer edge of the shoal, and the establishment of an efficient fog-signal are recommended, and an appropriation of $40,000 asked for this purpose.

Congress refused to honor the request. The following year the Board lowered its cost estimate to $30,000, without results. In 1876 only $25,000 was asked for, but again to no avail. By 1877 the price had gone to $20,000. For five more years the Lighthouse Board repeated its demand. Finally, in 1882, Congress made $25,000 available, and construction was started.

A caisson 35 feet in diameter was sunk three feet into the sand and a red brick house and lantern built on top of this foundation. The light on shore was eventually dismantled. Electricity was supplied to the 51-foot tower in 1929, and automatic operation was begun in 1963. A one-second white flash is exhibited every six seconds, and a foghorn blasts every thirty seconds except during the relatively fog-free summer months.

In the rain, looking toward Sandy Point
State Park and the site of the first
lighthouse.

Bronze casters to rotate the lens,
producing a flashing light (no longer
used).

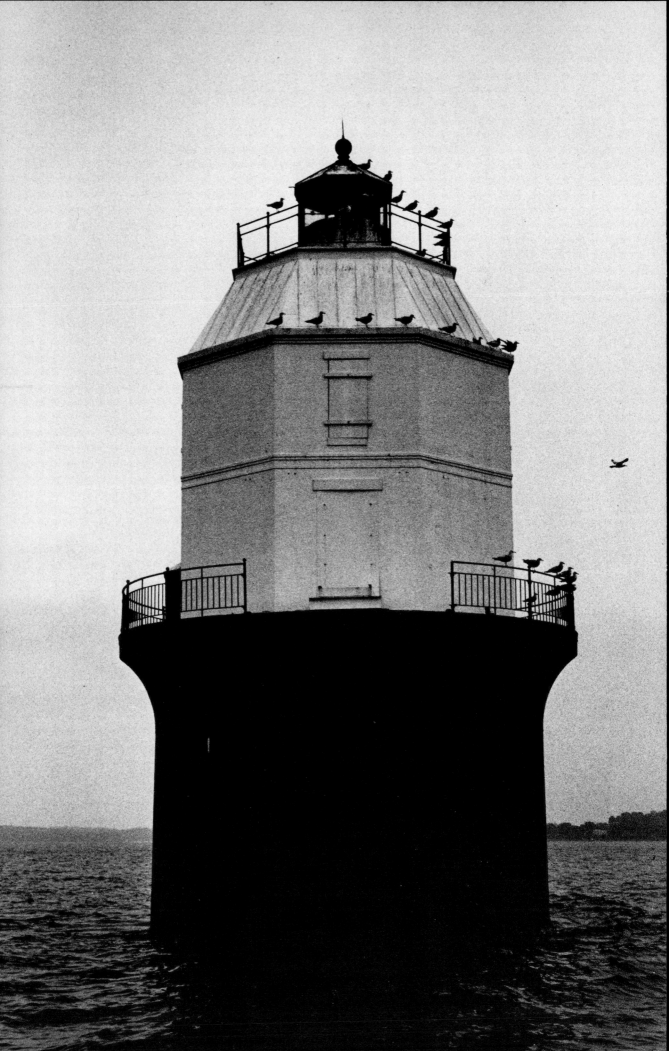

Baltimore

The Baltimore lighthouse, built in 23 feet of water on the western edge of the main ship channel at the mouth of the Magothy River, is a white two-story brick building erected on top of a cylindrical caisson base.

The first official request for a lighthouse here came in 1890, in the Lighthouse Board annual report:

The principal difficulty in the navigation of the New Cut-off Channel occurs at its junctions with the Craighill and Brewerton Channels. At these places the channel has been widened, and the intention is to still further increase the width. For vessels of small draught there is no difficulty in entering or leaving Baltimore Harbor. It is only in the day-time, when it is difficult to distinguish the buoys which mark the turning-points, and for large steamers, that additional aids to navigation are needed. A lighthouse is most wanted at the mouth of the New Cut-off Channel, i.e., where this channel joins the Craighill. On account of the impressible character of the shoal, and the liability to destruction or damage by fields of moving ice, no lighthouse, other than an expensive one, can be made permanent. The estimated cost of a suitable structure is $60,000, and an appropriation of this amount is recommended therefor.

Five years later, however, when borings were made at the selected site, it was found that a layer of soft mud extended 55 feet below the surface of the shoal, and the great depth to which the structure would have to be sunk compounded the problem. Another $60,000 was requested, and the design was finally approved in 1902.

Only one contractor submitted a bid, and it was nearly $80,000 higher than the $120,000 allotted. The bid was rejected and action suspended so that the contract could be readvertised and a satisfactory offer obtained.

Almost two years later, in early 1904, a contractor was found who claimed he could build the light within the budget. The caisson foundation was prefabricated and towed to the site on September 19, 1904. Two days later heavy seas filled the cylinder and caused it to settle to one side, nearly seven feet out of level. The bottom of the caisson was by then already eight feet into the shoal. Attempts were made to straighten it by placing concrete on the high side, inside of the cylinder, but on October 12 the caisson turned over completely. The disgusted contractor abandoned his attempts, defaulted on his contract, and was sued by the government.

The insurance company which bonded the contractor, in an attempt to recover some of its monies, spent the next three years trying to right the caisson, using various counterbalancing methods. Heavy weights suspended from wire cables were secured to the structure and led over A frames, and 80 tons of large stones were placed on the high side. Mud was pumped from underneath. The effort succeeded, and the foundation was righted. On June 30, 1907, it was reported that the caisson was only six feet out of level. The worst was over, and the building progressed smoothly after that. On October 1, 1908, the lighthouse was commissioned. It was the last lighthouse built in the Chesapeake Bay.

A string of geese passing the lighthouse
on the way to winter quarters on the
Eastern Shore.

Beaded tongue-and-groove siding on the
stairwell, with wide handrail for use as a
shelf.

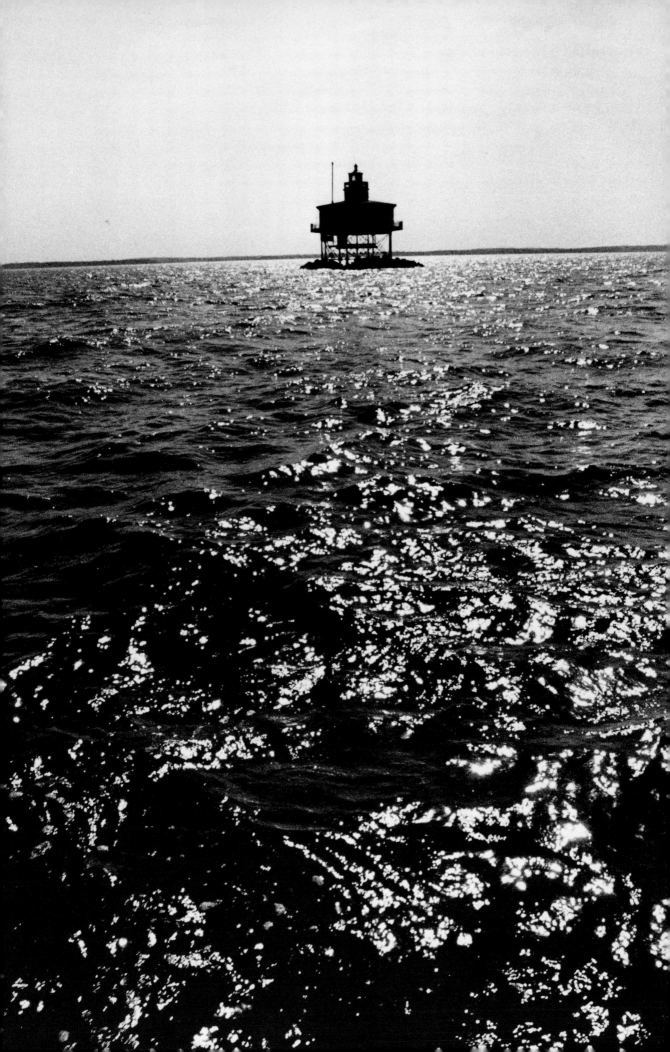

Sevenfoot Knoll

The officer of the Lighthouse Board who, in the mid-nineteenth century, surveyed possible new sites for a lighthouse at the mouth of the Patapsco River insisted on several things: that a screwpile lighthouse like the one erected at the Brandywine Shoal in Delaware Bay be built; that its height above the high water mark be 40 feet; that the light should be a third-order Fresnel lens, either fixed or revolving; and that the light be considered not merely a local accommodation to the bay craft and coasters but as the principal guide to the foreign shipping of the port of Baltimore.

Early in 1852 the Lighthouse Board considered signing a contract with one Theophilus E. Sickels, a civil engineer from New York, who proposed, for a fee of $27,000, to build a 60-foot brick tower atop a screwpile foundation. The agreement further stipulated that the lighthouse should stand in good condition for three years after its completion. Luckily for the over-optimistic Mr. Sickels, the Board reconsidered and instead awarded the contract in May, 1854, to the less grandiose design of Messrs. Murray and Hazelhurst, of Baltimore, who submitted the successful bid of $30,340. The 42-foot-high round screwpile light was built in eight feet of water. It was finished in 1855. It received only a fourth-order Fresnel lens, however.

Sevenfoot Knoll was the second screwpile lighthouse to be built on the Chesapeake, and it has survived longer than any other. The Coast Guard donated it to The Mariners Museum in 1971. Next year the building will be moved on a barge to Lake Maury, a land-locked pond on the museum grounds in Newport News, where it will be completely restored and will become a major exhibit, like the old Hooper Strait lighthouse at the Chesapeake Bay Maritime Museum.

Looking down at the riprap stone
protecting the lighthouse.

Metal ladder at the entrance to the
lighthouse, leading to the hatch and the
gallery.

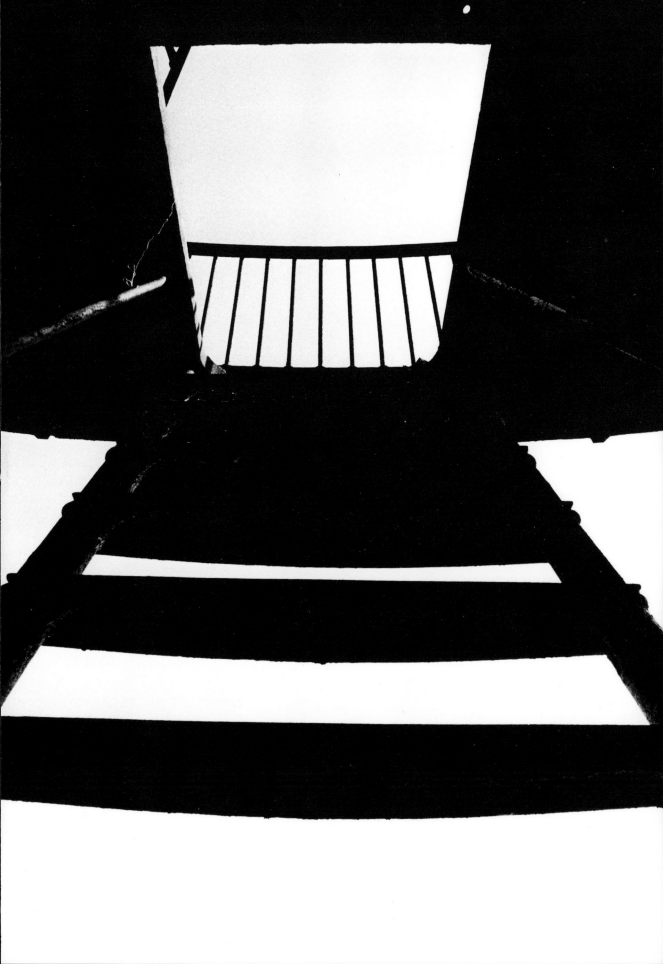

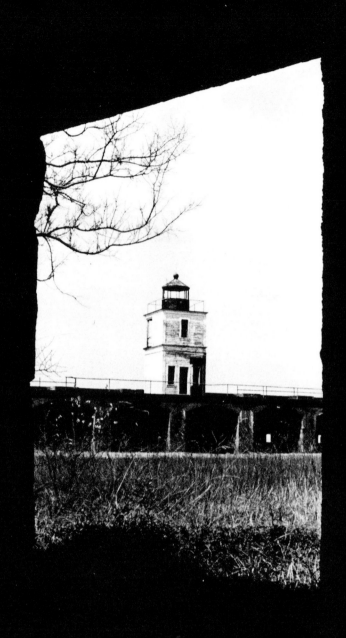

Fort Carroll

Fort Carroll is a man-made, unfinished, six-sided island fortress in the middle of the lower Patapsco River at the edge of Baltimore Harbor. Preparations for its construction were begun in 1847. The following year Robert E. Lee, who had distinguished himself during the Mexican War but was still only a brevet-colonel in the Army Engineers, was chosen to supervise the building of a bastion to help defend Baltimore in future wars. He began his assignment on November 15, 1848. For the next three years he commuted from the fort to his town house in Baltimore.

Progress was slow. The design called for a four-story, 40-foot-high fort of tiered galleries that would be able to hold 350 cannon. The island was to cover four acres, and each of its six sides was to be 246 feet long. By 1851, more than $1 million had been spent, and only the foundation and the first story were completed. Congress began having second thoughts as to whether the fort should not be located near the Virginia Capes, where it could protect more than one port against foreign navies. However, unable to decide anything, Congress did nothing. Lee was appointed to the superintendency of West Point, and construction was halted.

The lighthouse was built on the fort's unfinished parapet in 1854, and the keeper was its only permanent resident. In 1898 the Army Engineers made some minor improvements. The Spanish-American War was in progress, and the lighthouse and fog bell tower were torn down on October 17, 1898, to make way for two batteries, which were constructed and manned. A temporary lantern was installed and used until, in December, the lighthouse was rebuilt. It was a wooden tower erected about 100 feet north of the site of the old structure. The fog bell, which had been rung by hand, was also placed on the tower and operated by machinery. A fifth-order Fresnel lens was installed 45 feet above the water. During World War I the gun batteries were reactivated and used for firing practice. In World War II the Coast Guard used the fort as a pistol range and as temporary housing for seamen whose ships had to be fumigated. After the war the lighthouse was discontinued.

In 1958 the government sold the entire fort and the lighthouse to a Baltimore attorney for $10,000. Some needed repairs were made, and the fort was opened to visitors, who were transported there via hydrofoil. The venture lost money, and the tours were halted. Many uses have since been suggested for the fort, ranging from a marina, penitentiary, or summer theater to a museum. The fort and the square wooden lighthouse are still abandoned, vandalized monuments to bad planning and worse luck.

Segmental brick arches of the fort's
only completed tier.

The dilapidated entrance to the tower.

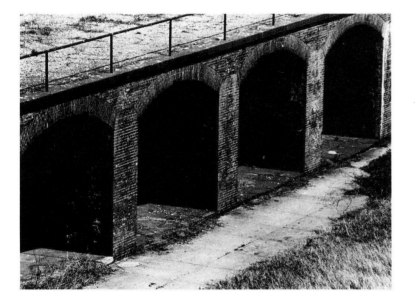

Craighill
Channel
Upper
Range

Until 1886, when these new lighthouses were built, they were called the North Point Ranges. With the new towers came a new name, Cut-Off Channel Front and Rear Lights, because they indicate a cutoff from the main channel into the Patapsco River, which allows a ship to steer safely inside the Sevenfoot Knoll lighthouse and so cut several miles off the route to Baltimore.

The front light, still sometimes called North Point or Fort Howard light, is an octagonal brick tower, 18 feet high (27 feet high when first built) with a white horizontal band painted around the middle. It was built on the foundation of the old Western North Point lighthouse. The rear light, 1.3 miles northwest, is located on Sparrows Point, the site of one of the world's largest steel mills. It is an iron frame tower in the form of a frustum of a square pyramid, with an inner wooden shaft covered with corrugated iron, resting on a stone and brick foundation. The light is 74 feet above ground. The keeper's house was torn down in the 1920s.

Work on the front beacon and the dwelling (which was on shore) and the rear beacon and keeper's house was begun in August, 1885. It was first proposed to use the western tower of the old North Point Range as the front light of the new range, with the necessary modifications, but a careful examination showed it to be entirely unsuitable for the purpose, and so a new tower was built on its foundation, which was still entirely secure. The workmen were transported each day from Baltimore via a steam launch. Progress was excellent, and on January 15, 1886, the lights could be exhibited for the first time from both towers; they were locomotive headlights; the front light was 25 feet above water and the rear light 65 feet.

A severe storm on August 28, 1893, carried away the bridge connecting the front beacon with the shore. It was deemed best to fit the little lighthouse for occupancy by the keeper rather than trying to rebuild the bridge and purchase a new right-of-way (which had also been washed away). A boat was bought for the keeper, davits installed, and a small boat landing built.

Early in this century both lights were automated, and in the late 1930s the front tower was demolished and a lower octagonal tower built on the original foundation. Both lights still show a fixed red light of 60,000 candlepower 24 hours a day.

Looking across Old Road Bay toward the
front light.

The rear light, seen through the square
window of its corrugated iron tower.

The octagonal brick front light, with
cranes on Sparrows Point in the
background.

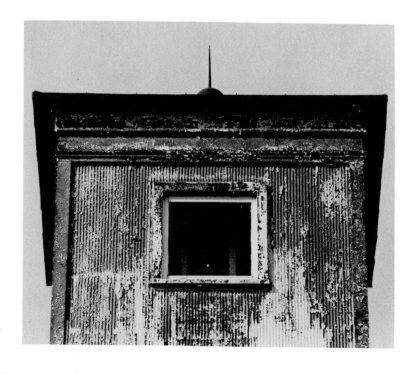

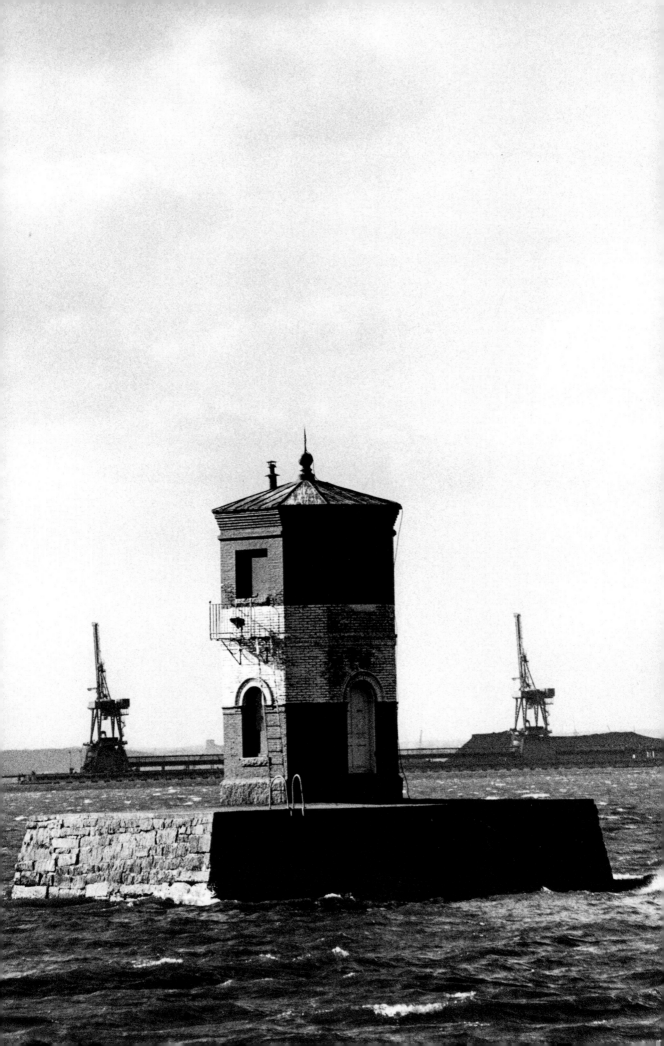

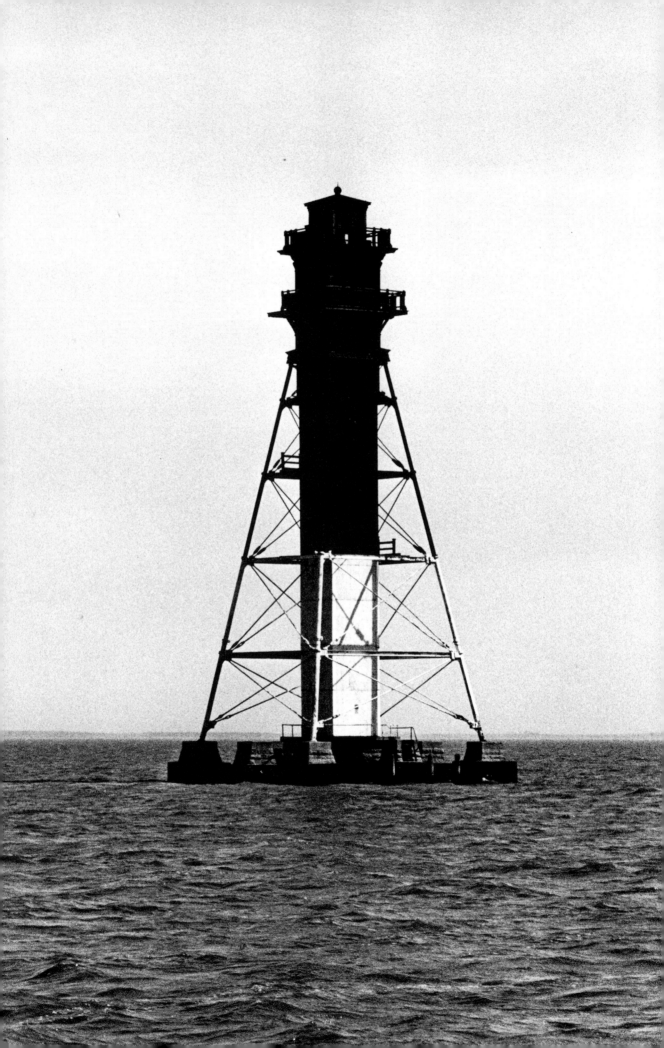

Craighill Channel Range

These two lights, one of three sets of old range lights, all in or near Baltimore Harbor, were built in 1873. The Craighill Channel, named after William Price Craighill, a member of the Lighthouse Board, and a major in the Army Corps of Engineers, starts at the mouth of the Magothy River and is the first leg of the entrance route to the Patapsco River and Baltimore Harbor.

Major Craighill, who was at one time in charge of Fort Carroll, supervised the surveys relating to the widening and deepening of this channel. The front light, 2.4 miles due south of the rear light, was originally designed as a screwpile foundation light, but the severe winter of 1872-1873 made the Board decide to erect a tiny caisson structure instead. Said one keeper, "It's so small, everytime you sneeze, you have to swab the place." The rear light, at 105 feet one of the highest towers on the Bay, has an intensity of 250,000 candlepower. It is a square pyramidal skeleton tower, built on nine piers of Port Deposit granite. Until the late 1930s it had a keeper's house a few feet above the water between the bases. Both lights are unattended now; the front light is unique in that it has two lights, one at 22 feet and one at 39 feet. The lower light works in conjunction with the range guide, and the upper light allows navigators to see the lighthouse when coming from a direction outside the range.

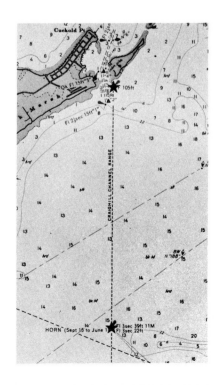

The front light, looking from the top of the rear light, 2.4 miles away, with the Chesapeake Bay Bridge barely visible in the background.

Warnings to trespassers on the metal siding of the rear light.

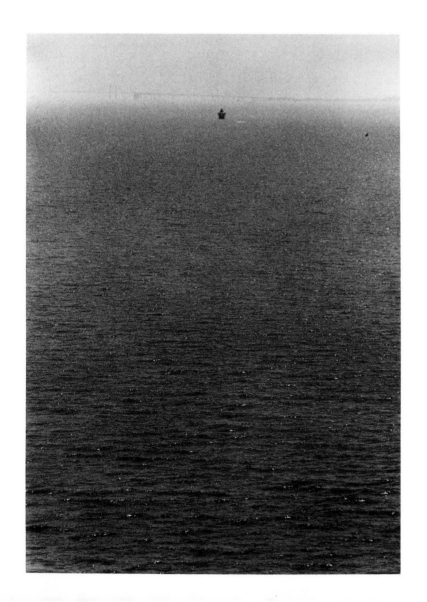

Pooles Island

This island in the upper Chesapeake Bay was first visited by Captain John Smith during his exploration of the Bay in 1608 and was named after Nathaniel Powell, one of the men who accompanied him on his voyage. The map that Smith published in 1612 shows the island as Powels Iles. The plural remains unexplained, unless the marshy middle of the island made it look like two islands from the water. Spelled Pools Island in 1843, Pooles Island in 1856, Pool's Island in 1867, Poole's Island in 1882, since 1892 it has been spelled Pooles Island again. The lighthouse was built by John Donohoo in 1825 for a little less than $5,000, plus $500 for the land. There had been a small settlement on the island since the early eighteenth century; in fact, it had been plundered by the British in 1813.

It was common practice to dismiss keepers summarily, often for political reasons. On appointing a new keeper to the light in 1843, Stephen Pleasonton, then in charge of the lighthouse service, wrote to the superintendent of the district: "I enclose the appointment of Ezekiel Morrison, of Harford County, as keeper of Pools Island lighthouse, vice William Reed, removed; together with a copy of Instructions for the former, and the letters of removal for the latter; all of which you will be pleased to deliver, and to admonish Mr. Morrison of the necessity of residing and being himself steadily in the house provided for the Keeper."

In 1873 7,000 peach trees were planted on the island, which then contained 280 acres (of which 200 were already in cultivation); in the last hundred years erosion has reduced that acreage somewhat. After the peach trees matured and bore fruit, Pooles Island peaches became a delicacy prized in Baltimore markets. The light was automated and the keepers removed in 1917, at which time the island became the property of the Aberdeen Proving Ground. The Proving Ground is spread over 82,000 acres (more than half of which is water), and extensive testing of new artillery, rockets, and amphibious vehicles is conducted here. The island is off limits to civilians.

The lighthouse continued its unattended operation until 1939, when it was permanently closed down and the lens removed.

Looking north from the top of the tower.

Hooked iron sliding bolt of the door of the gallery.

Havre de Grace

For nearly a hundred years the Havre de Grace lighthouse, at the entrance to the Susquehanna River, was called Concord Point, a corruption of Conquered Point, the name given this waterfront area in the seventeenth century.

When the government decided to build a lighthouse here, it sent a Treasury Department agent to buy the necessary land. "I paid a visit to Havre de Grace," he reported, "the proposed scite [sic] for a Lighthouse. I found as is usual when Government want property, that it had increased in value in so prompt and extravagant a manner as to render the probability of a purchase quite impracticable." Nevertheless, a small plot was purchased, and in 1827 the 39-foot tower, built for $3,500 by John Donohoo, was finished.

The light originally had nine lamps with 16-inch reflectors. In 1855 a steamer's lens was installed, and sometime in the 1870s a tiny sixth-order Fresnel lens was substituted. In 1892 this lens was exchanged for a fifth-order lens, and since then a fixed green light has been shown from the tower.

One of the authentic heros of the War of 1812 was John O'Neill, an Irishman who singlehandedly defended Havre de Grace against the British fleet in May of 1813. In recognition of his valor in resisting the might of Admiral Cockburn's guns, he was given the job of lighthouse keeper by the grateful townsmen, and until the light was automated in the 1920s his direct descendants held this post, a situation unrivaled in the history of Chesapeake lighthouses. When O'Neill died in 1838, his son John, Jr., got the job; when he died in 1863, his widow, Esther O'Neill, became keeper; when her son Henry was old enough to carry on the tradition, he took the post and held it from 1878 until 1919; then his son Harry, John O'Neill's great grandson, took over. Havre de Grace is no longer an important port, and the lighthouse (the keeper's house has been torn down) sits forlorn and all but forgotten on the water's edge, surrounded by junked bulldozers and cranes. It is due to be replaced soon by a post light on a small steel tower, but the building itself will undoubtedly be preserved and restored by the local historical society.

Looking toward Carpenter Point and the
Northeast River in early morning.

Brass frame of the fifth-order Fresnel lens.

116

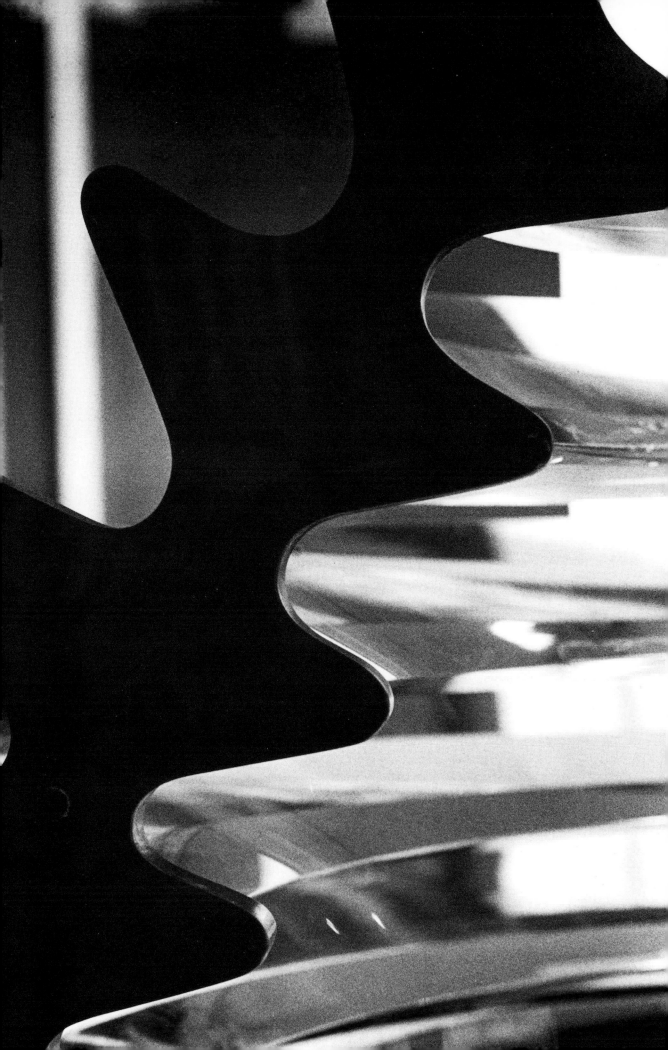

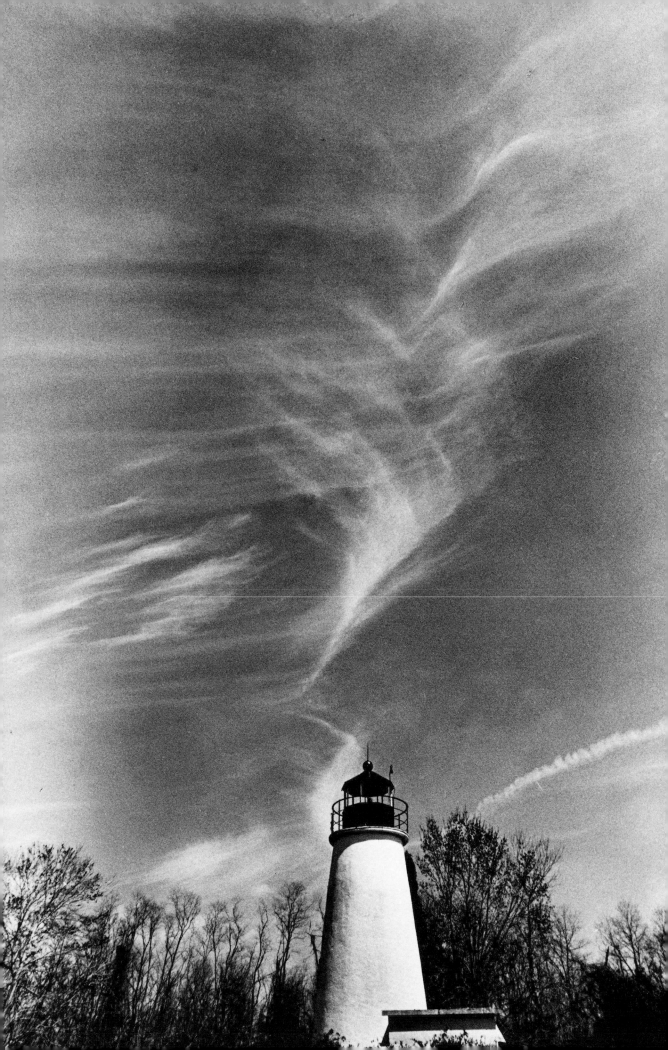

Turkey Point

Turkey Point, "high and timber-clad," between the Elk and Northeast rivers, is almost at the head of the Chesapeake. The lighthouse and the keeper's quarters were built in 1833 for $4,355 by John Donohoo. The tower is only 35 feet tall but stands on a sheer 100-foot bluff, making the flashing white light one of the highest on the Bay, if not one of the most prominent (the 1972 *Light List* cautions that the light is "partly hidden by foliage").

Probably because of its protected location and ease of access, Turkey Point had more female keepers than any other lighthouse in the Chesapeake area. The first was Elizabeth Lusby, who held the post from 1844 to 1861. John Crouch was appointed in 1865, and when he died in 1873, his wife got the job and held it until 1895. From 1895 to 1919 Mrs. Clara Brumfield was keeper. The last woman to serve at the Turkey Point light—in fact, the last woman to serve in the lighthouse service on the Chesapeake—was Mrs. Harry Salter. Her tenure was personally granted in 1925 by Calvin Coolidge after the death of her husband. When interviewed after her retirement in 1948 Mrs. Salter was quoted as saying, "Oh, it was an easy-like chore, but my feet got tired, and climbing the tower has given me fallen arches." She died in 1966.

The lighthouse was finally electrified in 1942, and after Mrs. Salter retired the light was automated, the house and outbuildings were demolished, and the central brick staircase was even torn out of the tower to prevent unauthorized entry. The Coast Guard Aids to Navigation crew uses a portable ladder to service the light.

Turkey Point lighthouse is located in the remotest part of Elk Neck State Park, one of Maryland's largest and most beautiful game preserves. The elks are no more and the wild turkeys are becoming scarce, but a healthy deer population still roams around the lonely lighthouse.

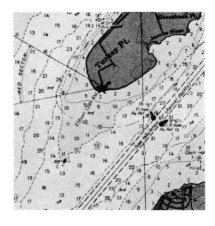

Looking south down the Bay, from
one of its highest points.

Close-up of one of the six-inch-square
ventilators inside the lantern.

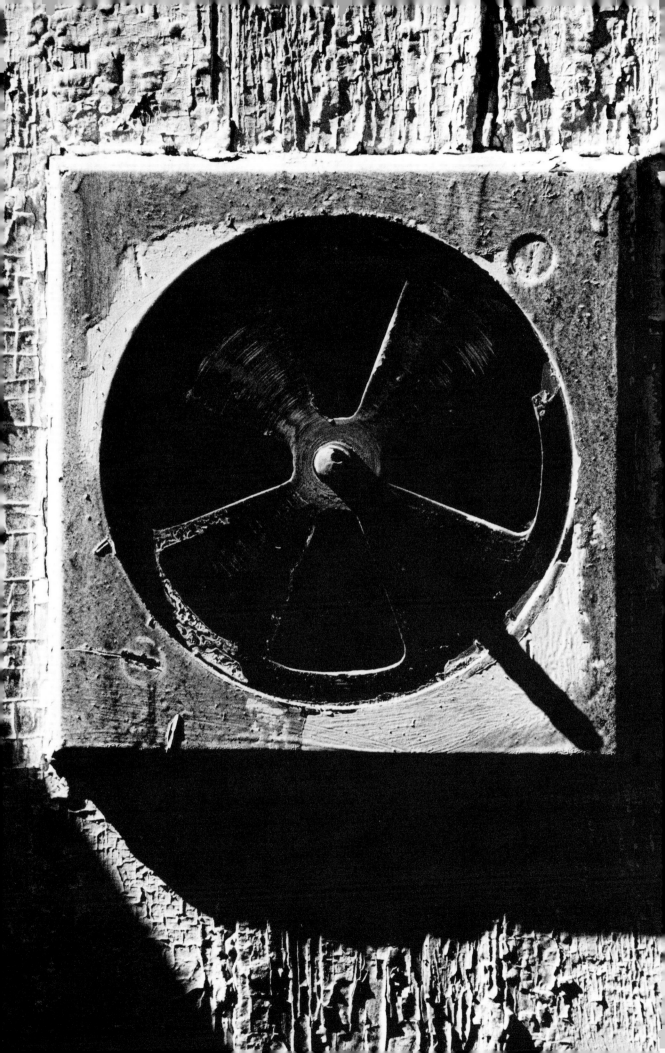

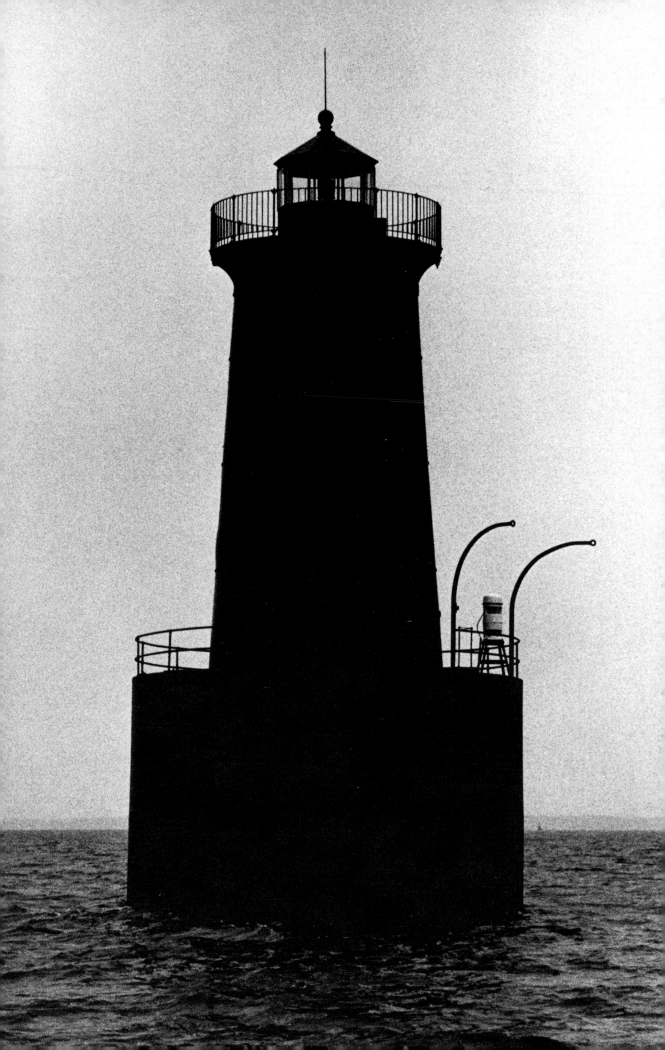

Bloody Point Bar

Locally referred to as the "coffee pot," Bloody Point Bar light is located in seven feet of water near the southern tip of Kent Island. It is a 56-foot-high round tower built on a caisson foundation. It flashes a white light every six seconds, and from September 15 to June 1 its foghorn blasts every 30 seconds, day and night, fog or no.

The tower was constructed in 1882, and cost $25,000. Only two years later it was discovered that it had begun to lean. It eventually came to rest at a slant more than five feet from a true vertical. In November, 1884, in an attempt to straighten it, sand was dredged from underneath one side until the tower began to settle back in the proper position. The operation was not entirely successful, however. The Lighthouse Board inspector wrote that "the inclination is less than one-half as great as before." In the following spring 760 tons of large stones were deposited around the structure to help prevent further scour and settling, but today the "coffee pot" still leans to one side.

On April 30, 1960, fire broke out in the tower. The electrical wires connected to the light were shorted out, and the fire swept toward the propane gas tanks. The keepers, two young Coast Guardsmen, tried to fight the blaze with fire extinguishers, but the smoke became too much for them. They abandoned the station and made their escape in an outboard motor boat. Shortly afterwards the propane tanks exploded. "We started the motor and I looked back," Mark Mighall, the nineteen-year-old assistant keeper, recalled later. "The lighthouse had become a tower of flame. It was awful watching your station burn." It was several hours before the fire had spent itself. The lens toppled into the blazing interior, and only the shell of the lighthouse was left. A temporary bell buoy with a flashing light was immediately placed nearby. In the fall the lens and light were replaced, and the station began unmanned, automatic operation.

Kent Point, at the southern tip of Kent
Island, in early morning drizzle.

Looking straight up from the center of
the lens toward the opening to the ceiling
ventilator.

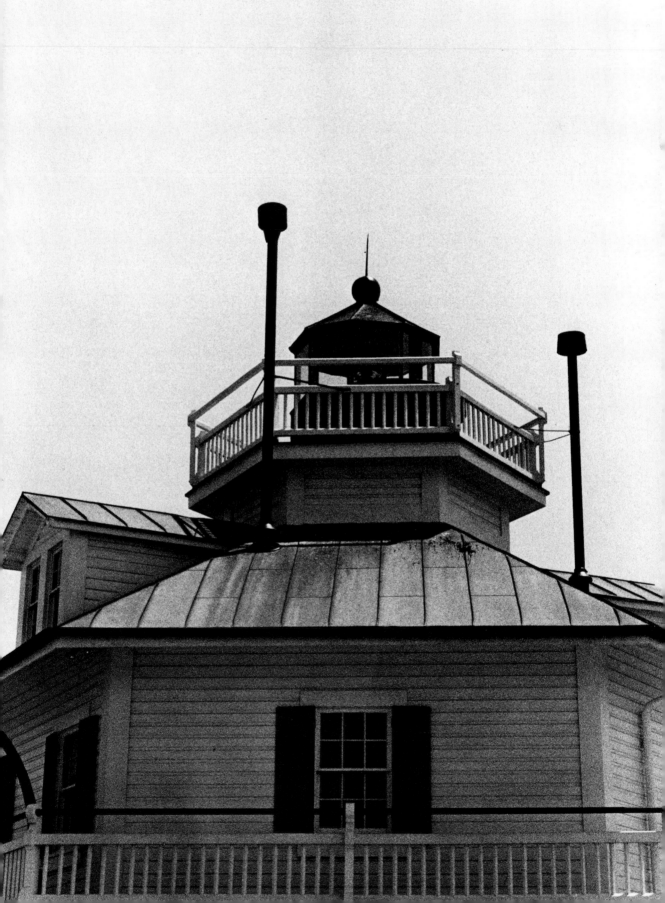

Hooper Strait

Hooper Strait runs between Bloodsworth Island on the south and Hooper Island and Bishops Head on the north and is the most direct passage into Tangier Sound when sailing from the northern part of the Chesapeake. From 1827 to 1867 it was the site of the only lightship ever stationed in Maryland waters (except for the Potomac), which indicates the importance of this narrow and crooked channel to shipping in the nineteenth century.

A screwpile lighthouse was built here and first lighted on September 14, 1867, and the lightship service was ended. The lighthouse stood for only ten years: on January 11, 1877, a large moving ice mass carried the building away. It was found several days later, five miles to the south, by a lighthouse service tender. The lens, lantern, and some items of furniture were recovered from the wreckage.

Two years later, on October 15, 1879, a new 41-foot-high hexagonal screwpile lighthouse was built in nine feet of water near the original location. This light was automated in 1954 and seemed to be doomed to the fate of most other Bay screwpile structures—eventual demolition and replacement by a more modern and less costly beacon—but the Coast Guard declared Hooper Strait surplus property in 1966, and the Chesapeake Bay Maritime Museum acquired it and decided to move it to their grounds in St. Michaels, 60 miles up the Bay.

The lighthouse was cut in half right under the eaves, completely disassembled, loaded on a barge, and floated into the Miles River. A new foundation was built on Navy Point, near the main exhibit area of the museum, and the lighthouse was erected on top of it. Although it took nine days to saw the building in half, it took only two and a half days to reassemble it. The whole venture cost $26,000, nearly twice as much as the original cost of the lighthouse. The 42-ton building, 44 feet in diameter, is now restored to its original condition, and sits high and dry on the edge of the Miles River. It has become a favorite attraction at the Museum.

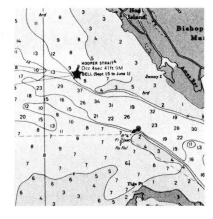

The Miles River from the top of the
lighthouse.

Rainwater collected from the roof passed
through gutters and downspouts to
wooden water tanks.

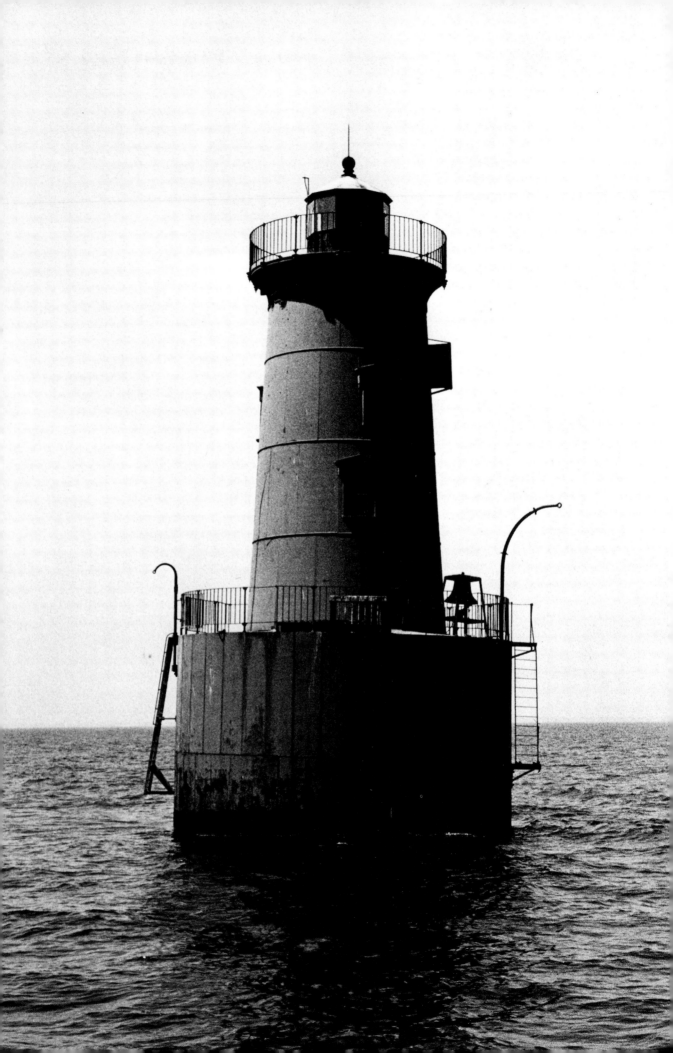

Sharps Island

Sharps Island, on the eastern side of the Chesapeake near the southern tip of Tilghman Island, was named after Peter Sharpe, a Quaker "chirurgeon" who owned it before 1675, when it contained more than 700 acres. Three lighthouses were built on or near the island in a space of almost 50 years. By the time the first lighthouse was built, in 1838, the island's acreage had been reduced to 480 acres.

The light was built by Thomas Evans on 10 acres of ground purchased for $600. It was a small wooden house, with the lamp housing on top, 30 feet above the ground. The lighthouse service was well aware of the erosion problems on the island and insisted that "the building be made so it can be moved at anytime with ease in case of the water washing the earth away." It had to be moved further inland in 1848, at which time the island had been reduced to 438 acres.

In 1864 the Lighthouse Board reported to Congress that "the lighthouse at Sharps Island in Chesapeake Bay is in imminent danger of being destroyed by the washing away of the bank on which it stands. The district engineer is of opinion that it cannot possibly remain during the coming winter. He has therefore made arrangements to have a temporary light shown, on the destruction of the lighthouse." The lighthouse was reprieved, however, the following year. According to the Lighthouse Board annual report for 1865, "The unusual absence of storm-tides and heavy north-west gales during the past year accounts for the unexpected preservation of the present structure. The sea, however, is gradually but surely undermining the bluff, and has already reached one corner of the building, leaving no doubt as to the result."

In 1866 a new screwpile lighthouse was built in seven and a half feet of water; it too was ill-fated. On February 10, 1881, the house was lifted from its foundation by heavy moving ice floes, thrown on its side, and carried away. The keepers clung to the house for 16 hours, until it finally grounded on land. They were rescued and were able to recover the lens and much of the furniture. The commissioner of lighthouses "highly recommended" their conduct.

In the following year a third lighthouse was built and still stands, although it has begun to tilt. It is a 54-foot-high iron tower on a concrete-filled caisson foundation. It was first painted purple, for some reason, but now its color is a more dignified brown. The light flashes a white light every four seconds and is completely automated. The last Sharps Island lighthouse has survived Sharps Island itself: by the early 1940s the island had completely disappeared.

A few minutes after sunrise, looking
toward the mouth of the Choptank River.

Looking up from the gallery past the
cast-iron window frames toward the
lighthouse top.

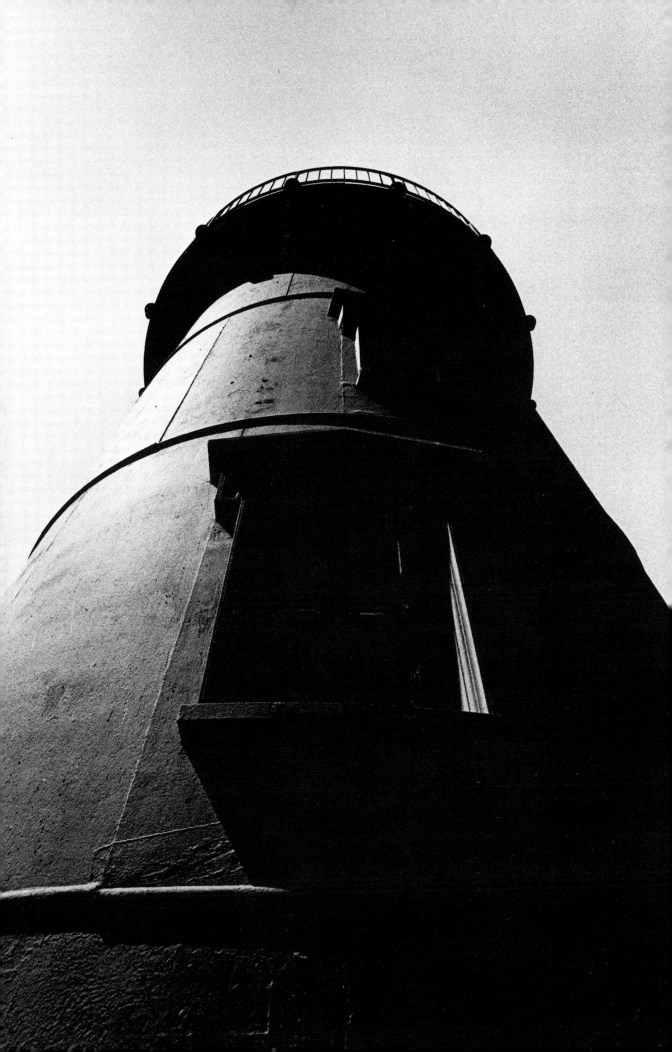

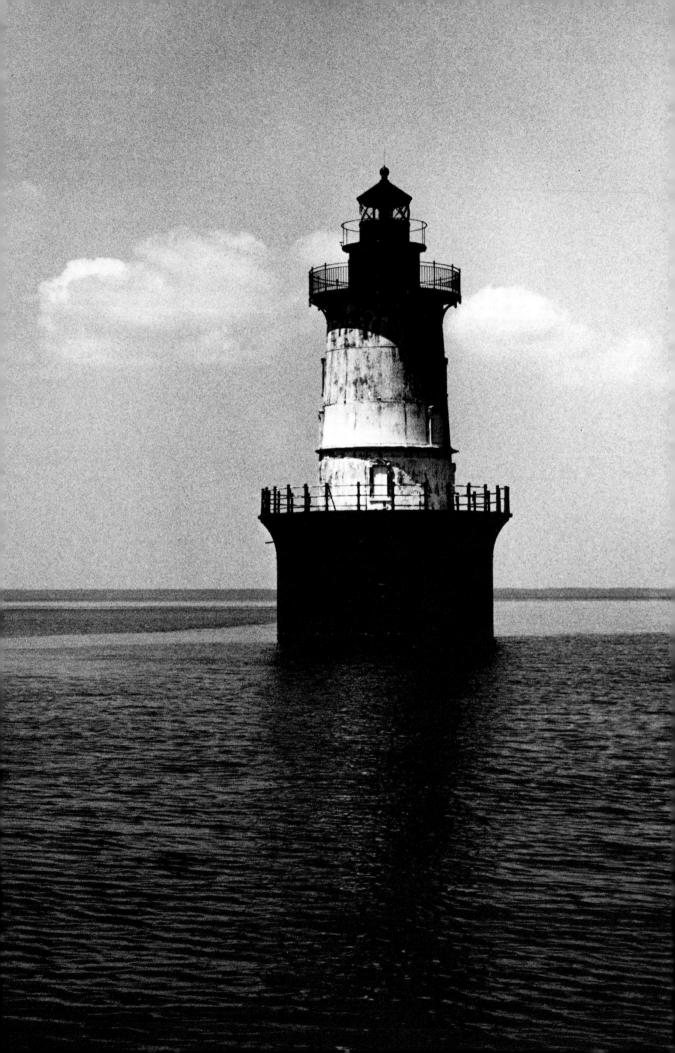

Hooper Island

There is a stretch of about 30 miles between Cove Point and Smith Point which should be better lighted. For a part of the distance navigators are without a guide, where a deviation from the sailing course might carry vessels of heavy draft onto dangerous shoals. There are many of this class of craft trading to Baltimore, and the number is increasing. The shore on the west side of the bay hereabouts is bluff and can be more easily seen at night than that on the eastern side, which is low. The shoals to be dreaded lie along the latter, and a light placed near that vicinity would be a great aid to navigation. It is estimated that a proper light can be established here for not exceeding $60,000, and it is recommended that an appropriation of this amount be made therefor.

Thus the first request for a lighthouse near Hooper Island, exactly halfway up the Chesapeake, in 1897. Congress appropriated the required funds the next year, and in 1899 a construction contract was awarded.

The contractor failed to perform (he never even began the work), and it was not until June, 1900, that new bids were opened. On July 6, 1901, the caisson had been towed to the site and placed in position. On August 31 the required depth of 13 and a half feet was reached, and the work of filling the cylinder with concrete began. According to the contractor's later description, the new circular dwelling stood on a circular foundation pier 33 feet in diameter. It had a veranda, a watch-tower room, a circular cylinder, parapet, and a circular lantern. The lower portion of the cylinder was filled with concrete and contained the water cisterns.

On June 1, 1902, the 63-foot-high lighthouse, built in 18 feet of water, began operating. It originally showed a flashing white light magnified by a fourth-order Fresnel lens, but in 1904 the characteristic of the light was changed to a fixed white, varied by a white flash every 15 seconds. There also was a fog bell at first, but it was removed and a foghorn installed. The lighthouse is now operated automatically, with batteries and generators as its source of power.

Sun reflected on the water beyond the gallery.

Diamond-shaped panes and mullions of the lantern, almost identical with those at Thimble Shoal.

136

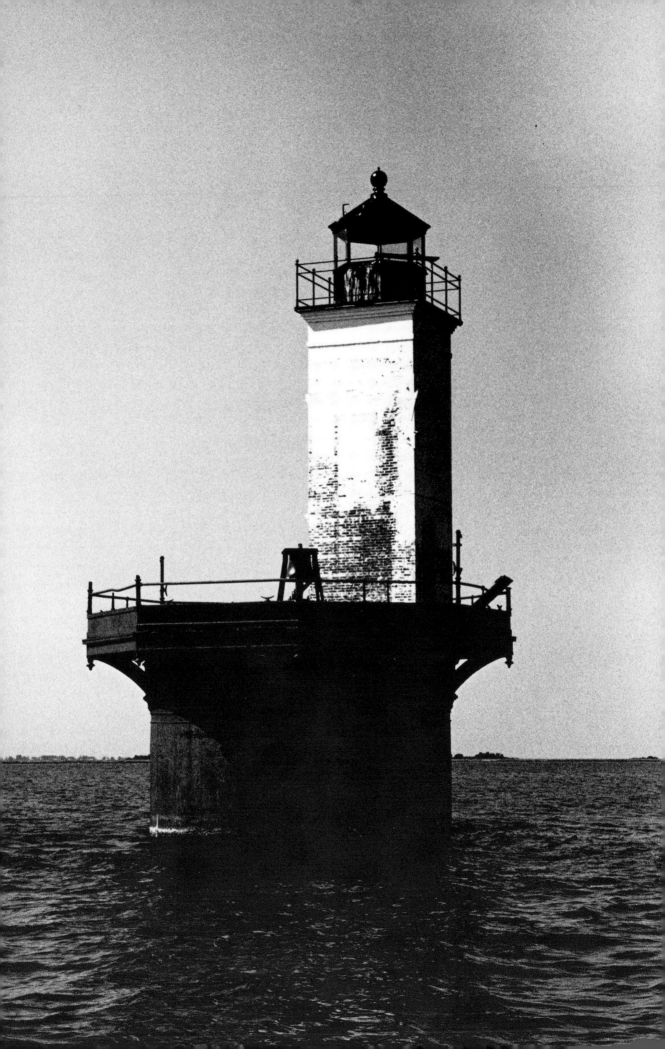

Solomons Lump

The present lighthouse is the second to stand on Solomons Lump, a shallow spot in Kedges Strait north of Smith Island, near the middle of the Bay. The first lighthouse was built in 1875 to take the place of Fog Point lighthouse, on Smith Island, which was discontinued at the same time. It was a small screwpile light, built at a cost of $15,000.

In January, 1893, it succumbed to the pressures of heavy ice, was sheared off its foundation, tipped over, and was carried away. The keepers escaped unhurt to Smith Island, less than 1,000 yards away. If fire or high winds and water were feared by lighthouse keepers in other parts of the country, ice was the greatest enemy of the lighthouses in the Chesapeake, and dozens were destroyed or damaged during heavy winters.

Construction of a new lighthouse began the following year, and on September 30, 1895, a 47-foot caisson tower, sunk in seven feet of water, was commissioned. The caisson is 25 feet in diameter, and the keeper's quarters were octagonal. The lighthouse was automated in 1950 and shows a flashing white light every six seconds.

Early morning, looking toward the
Eastern Shore.

The distorted shape of the electric light
bulb, seen through a modern, plastic,
Fresnel lens.

140

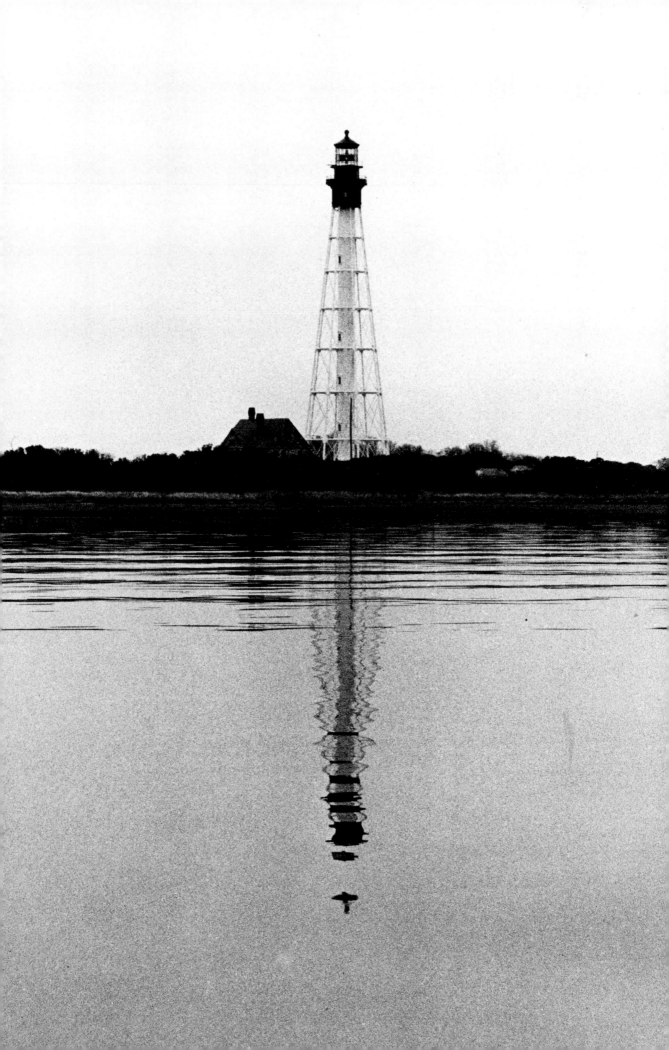

Although Cape Charles lighthouse, on Smith Island, is technically not a bay but a seacoast light, it marks, according to the *Coast Pilot*, the entrance to Chesapeake Bay. A 55-foot brick tower was built on the island in 1828 at a cost of $7,398.82, but from the very beginning it was considered inadequate, and frequent complaints about it were recorded. The report of the officers commissioned by Congress in 1851 to make inquiries into the state of the United States lighthouse system specifically mentions Cape Charles light and suggests that it receive "the earliest attention of the [lighthouse] department."

In 1856 Congress appropriated $35,000 to build a new tower a mile and a quarter southwest of the old structure. Construction was begun the following year, but progress was slow. In August of 1862 the project was interrupted by a Confederate guerrilla raid. According to the Lighthouse Board, the guerrillas completely destroyed the light and carried off whatever portable articles they thought valuable. The new tower had risen to a height of 83 feet, and most of the construction materials to complete it were stored on the ground, ready for future use. During the rebel occupancy they were also plundered.

An additional $20,000 was appropriated, and on May 7, 1864, the tower was completed and the light exhibited. "Owing to the liability of this important light to an attack from the enemy," the Board reported that year, "a competent military guard for its protection has been asked for." The sea turned out to be the greater enemy. By 1883 the high water mark had come to within 300 feet of the tower, and the sea was encroaching at a rate of 30 feet per year. Stone jetties were built, but in 1890 it was conceded that these measures could never fully solve the problem, and plans were drawn up for a new lighthouse to be built seven-eighths of a mile inland.

This third lighthouse cost $150,000 and was finished in December, 1894. Construction took longer than anticipated because flies and mosquitoes made work during the summer months virtually impossible. Its first-order Fresnel lens was not installed until the following year, and the light was shown for the first time on August 15, 1895. The tower is an octagonal pyramidal steel structure, 191 feet high. It was initially painted white with a red band in the middle—a marking called "conspicuous" in the 1902 *Light List*. Today the upper part of the tower is painted black and the lower part white. The station was converted to automatic operation in 1963, at which time the first-order lens was taken down and donated to The Mariners Museum, where it is now on display. Airport beacons were installed in its place, and they show a 1.2-million-candlepower light, the brightest by far of any lighthouse on the Chesapeake.

A tiny stream crisscrossing the marshes
which cover most of Smith Island.

The central column of the lighthouse,
supported by a maze of rods, pipes, and
turnbuckles.

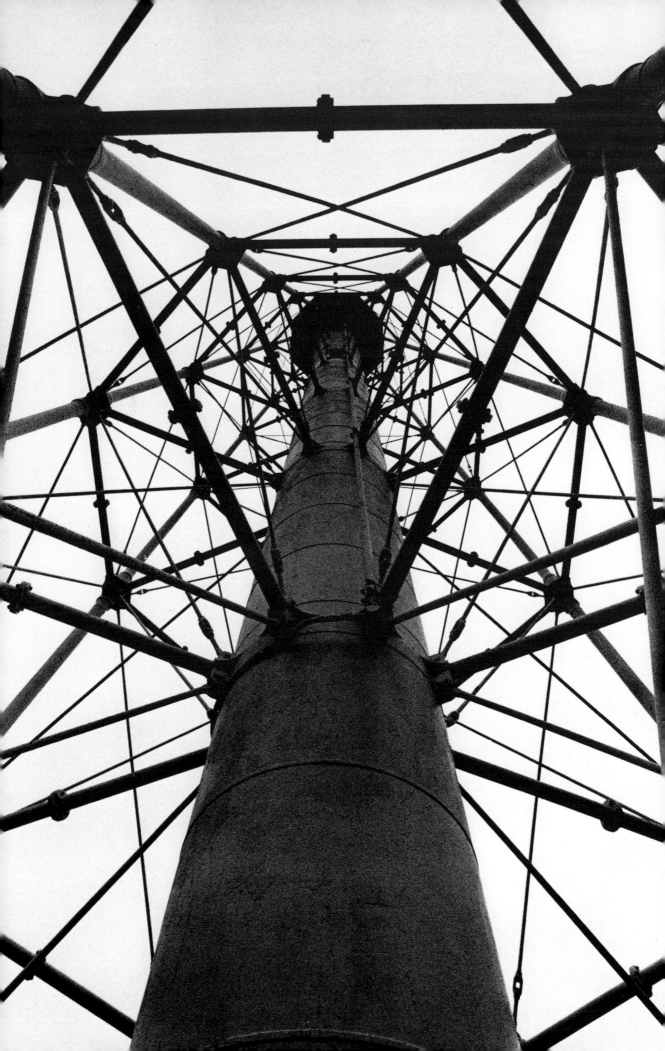

Destroyed

Lambert Point

Lambert Point lighthouse, on the Norfolk waterfront bordering the Elizabeth River, was completed in May, 1872. It was to serve the ever-increasing needs of shipping on the river. The original plan for this small screwpile light called for a foundation consisting of six piles. It was modified to five in order to make use of five old iron piles on hand. The change was a bad omen.

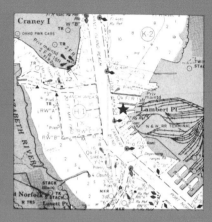

After a few months the building had settled more than a foot on one side. It was leveled without great difficulty, but over the years the light settled unevenly, and in 1866 it was suggested that it be abandoned when the Bush's Bluff lighthouse was completed. Because of increasing encroachment by coal piers and warehouses, the light had become relatively useless to navigators, and it was decided that a new lighthouse, on Bush's Bluff, would offer better guidance. However, soundings showed that the mud was so deep at Bush's Bluff that it would cost $125,000 to anchor the foundation. The project was therefore abandoned. (A lightship was later stationed at the shoal—from 1891 to 1918.)

The Lambert Point light was finally extinguished on New Year's Eve of 1892, but the building sat for years, at a crazy tilt, at the very end of a Norfolk and Western Railway coal pier. For some decades, beginning in 1901, it was used as a fog signal station, but it became apparent that it too, like the light, could no longer serve a useful purpose, and it was eventually discontinued and torn down.

Craney Island

Craney Island, near the Hampton Roads waterfront of Norfolk, was the site of the first permanent lightboat station in the United States. The vessel "of 70 ton burthen" with a lantern suspended from the mast had briefly been stationed at Willoughby's Shoal, but the location proved too exposed, and it was moved in 1820 and anchored off Craney Island.

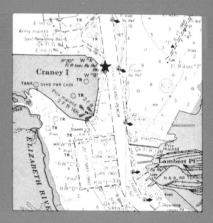

In 1859 a square wooden building on a screwpile foundation was built on the west side of the channel of the Elizabeth River, which divides the cities of Portsmouth and Norfolk. The lighthouse turned out to be far cheaper to operate than the lightship, and from then on lightships were phased out as rapidly as possible.

On the afternoon of September 26, 1870, Commodore Dornin, the inspector for the fifth lighthouse district, made an unannounced visit to the station. Part of his thirteen-page questionnaire, which is preserved in the National Archives, was concerned with morale:

Question: "Did the keeper make any complaint as to the capacity and attention to duties by the assistant?"
Answer: "None."
Question: "Did the assistant make any complaint about the light or its management?"
Answer: "None."

Those questioned were William P. Sturtevant, the keeper, and Mary, his young wife and assistant. Although wives often assisted their husbands in keeping the lights, this was one of the few cases where the wife was actually paid an assistant's wages. In 1884 the leaky and decayed superstructure was replaced by a hexagonal house, which survived until the mid 1930s.

148

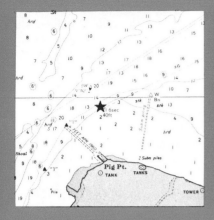

Nansemond River

The Nansemond River empties into the mouth of the James and is a shallow 15-mile waterway on which little traffic moves today except barges carrying clay, sand, and gravel. A hundred years ago the commercial waterborne traffic on the river was extensive, however, and in 1878 a lighthouse was built at the east side of the entrance to the river to help guide vessels into it. The hexagonal building, 36 feet high, on a screwpile foundation, contained a small sixth-order Fresnel lens and exhibited a fixed white light. It also had a fog bell, which was operated by hand when necessary. One of the few occurrences at the light deemed worthy of official note over decades of reports was an item published in the Bureau of Lighthouses annual report for 1914: "The keeper at this lighthouse, Charles A. Sterling, was cited by the Commissioner of Lighthouses for recovering a lady's wristwatch accidentally dropped overboard." The lighthouse was automated in 1935, after the superstructure had been torn down and a steel skeleton tower erected on the old foundation.

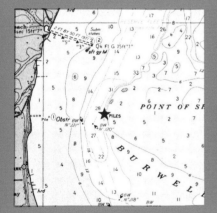

Point of Shoals

In 1837 Captain Alexander Claxton, a representative of the lighthouse service, while searching for eligible sites for new lights, suggested that three lighthouses be built in the James River but that "if it be intended to erect one light, and *only one*, then I would, in that case, recommend its being placed on the Point of Shoals, as it is the most dangerous situation on James River. On the Point of Shoals, the foundation is hard enough for a lighthouse; it is a firm oyster bed, dry at half tide, and only covered at high water about two feet." He went on to say that a lightboat might also serve and that the choice was a matter of economics: the lighthouse would be cheapest in the long run.

A small hexagonal screwpile lighthouse was finally built and first lighted about 20 years later, on February 6, 1855, and instead of Claxton's three, that year four lighthouses were built on the James. In 1869 funds were requested to rebuild the light: "This lighthouse . . . is at present in an unsafe condition, and it is probable that if the coming winter should be severe enough to form heavy ice, the lighthouse will be carried away when the ice breaks up. The lives of the keepers should no longer be jeoparded in this structure." It was rebuilt in 1871, automated in 1932, and dismantled when the shoaling in Burwell Bay became so severe that a new channel was dredged two miles east and the light became unnecessary.

Deep Water Shoals

Only the spider-like foundation of the old lighthouse remains at Deep Water Shoals, almost five miles up the James River from Point of Shoals. A red-and-white-checked daymark in 1966 took the place of the original house, which was built in 1855, the same year as Point of Shoals, White Shoal, and Jordan Point, the other lights on the James. The light cost $20,828.71, rather a lot at that time for a small screwpile lighthouse with a sixth-order Fresnel lens. In its first year of operation it was severely damaged by ice and storms, and it was completely destroyed by moving ice on January 20, 1867. An identical replacement was constructed and began operation a year later.

During the early years of the Civil War the lights on the river were discontinued and the apparatus taken down and stored at nearby Fortress Monroe. When the Army of the Potomac moved closer to Virginia, the James began to be used for transporting stores and ammunition, and all the lights were re-established. The Lighthouse Board in 1864 commented that "their permanency will depend on their protection from the enemy." In 1966 the building was torn down and a modern steel tower erected on its foundation; it had been automated many years earlier.

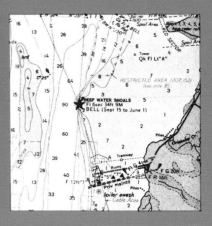

Jordan Point

Jordan Point lighthouse, on the south shore of the James near the town of Hopewell, only 20 miles from Richmond, was first established on February 7, 1855. Originally the light was on the roof of the keeper's house, but in 1870 there was an official warning that the water was making inroads upon the grounds and was within 15 feet of the lighthouse. The house was torn down in 1875 and replaced by a new dwelling and a separate tower, which was made of wood and decorated with intricately detailed scrollwork. The cost is given as follows:

two chimneys	$ 40.00
materials	$1,839.15
boat (to deliver materials)	$ 100.00
one captain, two hands, one cook, one steward	$ 174.65
one superintendent, eight carpenters, four laborers (40 days)	$ 960.00
subsistence (eighteen people for 40 days at 40 cents per day)	$ 288.00
	$3,401.80
15 percent for contingencies	510.27
total	$3,912.07

The house and the property (except for a small plot where the tower stood) was sold in 1927 for $1,105. The light was automated and in 1941 was replaced by a steel skeleton tower, which still serves as the Jordan Point Range Rear Light.

Back River

Back River lighthouse stood near the southern entrance to Back River, six miles north of Old Point Comfort. Four acres of land were purchased for $100. Three contractors bid on the job: John Donohoo, from Havre de Grace (who had built Cove Point light), submitted a bid for $4,725; Thomas Evans, from Baltimore (who had built the Bodkin lighthouse), bid $4,500; Winslow Lewis, from Boston (who had not built any lighthouses on the Chesapeake but was the inventor and supplier of the lamps and reflectors then in use), made the winning bid of $3,500 plus $750 for his lamps. Lewis was not familiar with the area and thought that the site was three miles farther north, where the water was deeper and he could easily land supplies and equipment from his boat. Instead, his materials had to be transferred to a small boat and then carried 800 feet to the construction site. That took 12 days, 10 days longer than Lewis had estimated, and he asked for a higher fee, but the contract read "at or near" Back River Point, and his request was denied. The project was completed late in 1829.

The tower was built close to the water's edge, but the keeper's house was located 144 feet farther inland. Because the property was low and marshy, a footbridge was built so that the keeper could reach the tower without a boat. At the request of the first keeper, William Jett, Lewis built a small porch on the front of the house for an additional $15. The keeper also asked for a small fence "to keep cattle out," which Lewis obligingly provided.

Mr. Jett was keeper until 1852, when he retired from the lighthouse service. In 1869 a lightning rod was installed on the house; the tower had had one since it was built. In 1894 the house was enlarged by one story to accommodate the keeper's growing family.

In the fall of 1903, during a severe storm, the house and the footbridge narrowly escaped destruction. A repair crew, working day and night for 72 hours, succeeded in saving the house and supporting the walkway, so that the tower could still be reached. Seas dashed to a height of 14 feet against the porch of the house and moved large stones from their places. The tin roof was partly torn off, and the gutters and downspouts were carried away. The tender *Thistle*, whose crew made up the repair party, parted her anchor lines and was driven ashore. She was refloated a few days later, but not without considerable damage.

The light was automated in 1915 and discontinued in 1936. Neglected, it fell into disrepair, and over the years wind and water took their toll. The buildings were completely destroyed during a hurricane in 1956. Only a pile of stones in the surf marks the remains of the 30-foot tower.

York Spit

Alexander Claxton, in a report to his fellow members of the Board of Navy Commissioners in 1837, was adamant: "A lighthouse on York River Spit is impracticable, and, if located on the main, *useless*, by reason of the winding of the coast, which would throw it entirely out of the ranges of vessels navigating the bay. By referring to the chart, forwarded some days since, it will be seen that this part of the bay is almost in a blaze of light establishments [there were precisely five]. Something should be left to the knowledge and judgment of the navigator, or otherwise every shoal, river, and creek must be lighted; an expense too enormous to be tolerated." Despite this protest, a lightship was placed on the spit in 1855, and there it remained until November 15, 1870, when a lighthouse was established "in 12 feet of water, on fourteen wooden piles encased in cast-iron sleeves." The construction crew had a hard time: the bottom was so hard, they said, that it took "243 blows of a 1600 pound hammer to penetrate the first pile twenty feet." The light was automated and dismantled in June of 1960.

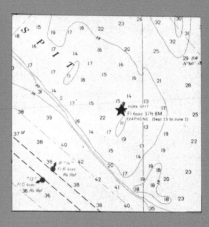

Tue Marshes

Tue Marshes light, spelled Too's Marshes until the beginning of this century, was located on the south side of the entrance to the York River. The rectangular gingerbread superstructure was removed, but the new automatic beacon, installed in 1960, is still supported by the old pile foundation. The lighthouse began serving the mariner on August 15, 1875, and had an uneventful history. It cost $15,000 to build.

Like many other lights, Tue Marshes has always had sectors of colored glass placed in the lantern to show light sectors of different colors. Both red and green are used, but red is more commonly used to mark shoals or to warn the mariner of other obstacles to navigation or nearby land. Such lights provide some bearing information: a change of color can be noted as the observer crosses the boundary between the sectors. The boundaries are indicated by broken lines on the chart, and the *Light List* makes note of it. It is impossible to determine accurately the point at which the color changes because the edges of a colored sector cannot be cut off sharply, and there is always, on either side of the line of demarcation, a small arc of uncertain color. Nevertheless, it can be helpful to the navigator, and about two dozen of the lighthouses on the Chesapeake show the red danger sectors.

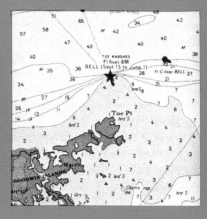

152

Pages Rock

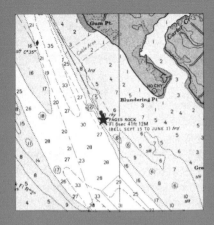

On September 30, 1893, Pages Rock lighthouse, five miles from York-town in the York River, was put in commission. It had been a long time coming. Eight years earlier, in 1885, the Lighthouse Board had stated in its annual report that the increasing commercial traffic on the river made a lighthouse necessary and that one could be built for $25,000. Congress finally approved the expenditure in 1891, and borings were made to ascertain the character of the shoal so that the necessary foundation could be determined. The result showed that the shoal was not sufficiently firm to hold a lighthouse on screwpiles. It was decided to support it on wooden piles which could be driven to a firm base more economically than the screwpiles could. Pine piles were driven six feet into the shoal and encased in iron sleeves. A fourth-order lens was installed on the 41-foot-high house. In 1967 a small flashing light was installed on the foundation, and the wooden house was dismantled.

Bells Rock

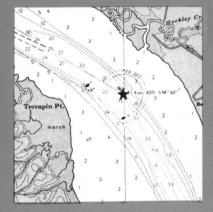

"To allow vessels to easily reach West Point, sea terminus of the Richmond and York River Rail Road," Bells Rock lighthouse was built in 1881, 20 nautical miles up the York River from Yorktown, at a cost of $31,186.64. Because it was in a protected spot and in only 10 feet of water, a screwpile design was decided upon. The house was hexagonal and only 40 feet high.

It had a quiet history, apart from an incident in June of 1884 when a schooner hit its foundation and broke three of the supporting columns. They were repaired a few weeks later. The tiny fourth-order light was sufficient because its approach is unobstructed for miles and the river is only a mile wide at this point. There is no longer much traffic on the York River except for pleasure craft. Those commercial vessels that do use it carry mostly pulpwood, crude oil, and oysters. In 1928 the super-structure was dismantled and an automated light on a steel tower erected on the pile foundation.

Stingray Point

Stingray Point light, a hexagonal dwelling on a screwpile foundation, was built in 1858 on the south side of the mouth of the Rappahannock River. It was dismantled in 1965, and a small automatic beacon was built on its foundation.

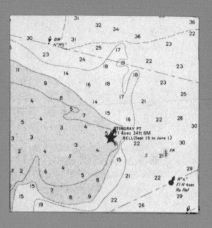

Probably the keeper with the longest tenure in one lighthouse on the Bay was Larry Marchant, who retired in 1920, after 38 years in the lighthouse service, the last 32 years of which he spent on Stingray Point. In an interview Mr. Marchant gave to a Baltimore *Sun* writer a few months after his retirement, he talked about his experiences at the lighthouse: "During very stormy weather, with the sea running high, the station shook badly. It is supported by six small iron piles and I have seen it sway back and forth like a rocking chair. The most lonesome time I experienced was during the winter of 1912, when I was alone for thirty days in a freeze. The tower shook while the ice drifted around the station and the Chesapeake was covered with ice as far as the eye could see. No kind of boats were passing and there was nothing to look at but fields of ice." He continued: "The life was somewhat lonesome, but the light station is furnished with a library of about sixty books. After the work of the day was over, I spent the rest of the day in reading. The libraries are exchanged from station to station about every three months, so I did not have to read the same books over." When asked about his health, Mr. Marchant commented: "During my long time in the Lighthouse Service I have not been sick a single day and have not lost a day's pay. The secret of my good health is that I have been where the doctors could not get to me."

Bowlers Rock

The Rappahannock River can be navigated for 93 miles, from the mouth of the river, between Windmill and Stingray Points, to Fredericksburg. Bowlers Rock was the only lighthouse ever built in or on the river, which is wide, straight and deep for most of its length. A lightship was stationed at Bowlers Rock from 1835 to June 10, 1868, when the screwpile lighthouse was commissioned. The lighthouse was built in six feet of water, almost 30 miles from the mouth of the river. Bowlers Rock is also occasionally referred to as Corner Rock.

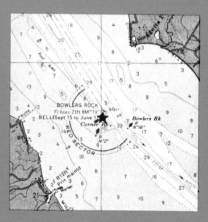

The Lighthouse Board report for 1895 made one of its infrequent references to Bowlers Rock lighthouse: "This is one of the older screwpile light-houses. It stands low in the water and the iron foundation suffered somewhat from the impact of the ice during the winter. Its age and position render doubtful its ability to withstand without protection another similar experience, and it was accordingly considered prudent to place masses of rip-rap stone in the axis of the current, to act as ice breakers." This was done as a matter of course around most of those screwpile lights in the Bay and its rivers which were vulnerable to ice damage. The light survived, with the help of the stone, for another 25 years. In 1920 a small skeleton tower on a cylindrical base was sunk into place nearby. It used acetylene gas and functioned automatically. The lighthouse was dismantled shortly afterwards.

Windmill Point

A lightship was anchored here at the mouth of the Rappahannock River from 1835 until 1861, when Confederate troops destroyed it. A small white hexagonal screwpile lighthouse, identical to the second Smith Point light, was built in 1869. A fixed white light and a fifth-order Fresnel lens were installed. The iron pilings were painted red and the superstructure a straw color, which had been the color of the lightship's hull.

A 1905 report to the Lighthouse Board mentions that "this is one of the oldest screwpile lighthouses in the district, and structurally is not strong." It survived, however, until 1965, when it was dismantled as part of the Coast Guard automation program. The foundation still supports a flashing white light and a fog bell.

In the early years of the lighthouse service, before the advent of electricity, fixed (steady and continuous) lights were more common than flashing (revolving) lights. Expensive and complicated winding machinery was required to allow the lights to revolve at accurate intervals. Electric motors now turn the lamp and often the reflector as well, although in the smaller beacons and buoys electronic circuits flash the lights on and off.

Great Wicomico River

The Chesapeake Bay area is rife with duplications of names. There are four Wicomico rivers in this area, although one is usually called Wicomico Creek and one Great Wicomico. The latter is on the western shore of the Bay, in Virginia, near the famous menhaden fishing port of Reedville.

There are at least ten Back Creeks and Back Rivers, a half dozen Broad Creeks, two Severn Rivers, four Deep Creeks, four Hunting Creeks, four Island Creeks, three Drum Points, two Sandy Points, and untold Fishing Points, Creeks, and Bays.

The lighthouse at the entrance to the Great Wicomico was built in 1889 and began operation on November 10 of that year. It was a small hexagonally shaped house on a screwpile foundation. It exhibited a fixed white light from a fourth-order lens and had two red sectors which warned of the shoals off Dameron Marsh and Bull Neck. A fog bell was sounded twice every 15 seconds when needed. The light was dismantled in 1967, although the foundation was retained as a support for a new beacon. The red sectors were maintained, but the light characteristic was changed to flashing white.

Ragged Point

Ragged Point was the last lighthouse built in the Chesapeake Bay area, although the initial request for its erection had been made in 1896: "This shoal makes off from the west bank of the river at a short turning point. It is important that this point be marked by a light at night and a fog signal during thick weather. It is estimated that a light and fog signal station can be established here for $20,000, and it is recommended that an appropriation of this amount be made therefor." The Lighthouse Board in 1901 complained that the cost of labor and materials had risen so much since the request was made that an additional $10,000 would be required for construction. In 1906, Congress appropriated the $30,000 needed for the lighthouse. When it was finally completed, on March 15, 1910, the total cost had risen to $34,223. The delay had cost the Treasury almost $15,000.

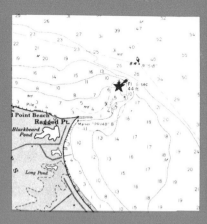

The hexagonal screwpile light was built on the Virginia side of the Potomac, off Coles Neck, a few miles across the river from Piney Point. It is ironic that this light, last to be built, was one of the first to be dismantled under the Coast Guard automation program. However, the foundation was retained as support for a 44-foot tower from which a white light still flashes.

Lower Cedar Point

This dangerous turn in the Potomac River at Lower Cedar Point was first marked, like several other danger spots during the first half of the nineteenth century, by a 72-ton lightship displaying a light from the top of its mast. It was placed here in 1837. Confederate rebels boarded and burned it in 1861; after the Civil War was over a small screwpile lighthouse was built in 1867.

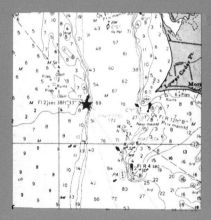

On Christmas Day, 1893, the lighthouse was destroyed by fire, the cause of which was never ascertained. The assistant on duty (the principal keeper was absent for the holidays) escaped with difficulty, but unhurt. After the fire a lens lantern was immediately placed on the substructure as a temporary marker.

It was thought at first that reconstruction would cost $75,000, and funds in that amount were appropriated, but the foundation survived the fire intact, and only $25,000 was spent on rebuilding the superstructure. Even so, the new light was not finished until September 5, 1896.

The house was eventually dismantled, but a light is still shown from a white skeleton tower at the height of the original lens, 38 feet, and the old screwpile foundation still supports this important navigational aid.

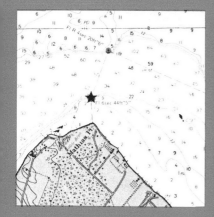

Mathias Point Shoal

A white light still flashes from the top of a steel tower built on the old pile foundation of the Mathias Point Shoal lighthouse, 47 miles up the Potomac River, at the entrance to the Port Tobacco River, at one of its more tortuous turns. The need for a light here was forcefully set forth in a request by the Lighthouse Board in its 1873 annual report to Congress:

This is one of the most difficult places for experienced navigators, who are familiar with the river, to pass at night. Few places occur where experienced pilots cannot tell where they are by soundings; at this place, however, soundings run from one hundred feet to five feet within a space of a hundred yards. The current, which is strong, sets directly on the flats, both at the flood and ebb tides, which renders it bad enough for sailing-vessels even by daylight, but at night the difficulty is much aggravated by the want of some guide to point out the dangerous spot. It is no uncommon sight to see a vessel aground on these flats. The United States naval steamer *Frolic* went ashore here during the summer of 1873, and remained for some time. It is recommended that an appropriation for $40,000 be made for a lighthouse at this place.

Apparently the argument, especially the mention of the *Frolic*'s mishap, was convincing, for in 1876 a lighthouse was in operation on the site. In 1951 the light was converted to automatic, unattended operation; in 1963 the house was dismantled and the new steel tower installed.

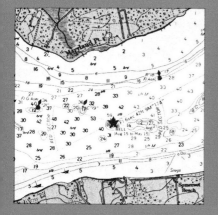

Maryland Point

"The channel of the river is quite narrow here, and there is but 10 feet of water on the apex of the shoal at low stages. Light-draught vessels can easily pass over the shoal, but vessels drawing more than 10 feet are liable to take the ground. The danger of vessels of heavier draught is so great, and there are so many plying on the river, that a light is needed here for the completion of the system decided on as necessary fully a dozen years ago." So argued the Lighthouse Board in 1890. On December 15, 1892, the small, white 42-foot-high hexagonal screwpile lighthouse, 56 miles up the Potomac River, was commissioned.

Screwpile structures were nearly all the same: four rooms and some closets on the first level and a staircase in the center leading to the second story, where the fog bell machinery was located and tools were stored. Another small room could serve as a bedroom for the keeper who had the duty. The house was surrounded by a gallery, from which the boats were suspended on davits. The pile foundation now supports a small automated light. The house was torn down in the mid 1960s.

Upper Cedar Point

The Potomac River was an important commercial waterway until well into the twentieth century, and ten lighthouses were built on the river between 1836 and 1910. As early as 1821 a 72-ton lightship was anchored at Upper Cedar Point, 33 miles below Mount Vernon, but it was replaced on July 20, 1867, by a more economical square screwpile lighthouse. Here John Wilkes Booth rowed across the river after assassinating President Lincoln and fleeing the Capitol. Here too, at Upper Cedar Point lighthouse, is the only known instance of Negroes serving as keepers under the Lighthouse Board. Its record, like many government and private organizations, was not a good one in regard to equal employment opportunities for minorities, but two young black men, Robert Darnell, the head keeper, and John Parker, his assistant, served here for several years in the 1870s.

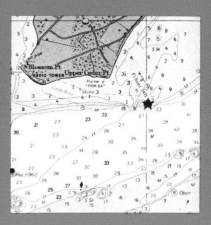

After the Mathias Point Shoal light was built in 1876, Upper Cedar Point was discontinued. Mathias Point is two miles downriver from here and was considered a more useful location. After repeated requests from ship captains, the wicks were lighted again in 1882, and the light served until 1963, when the house was dismantled and a modern beacon light installed on the screwpile foundation.

Cobb Point Bar

Three steamboat lines run regularly into the Wicomico from the Potomac River, doing a heavy carrying trade in oysters, tobacco, and other productions. As many as 350 vessels have anchored at one time inside the bar. This is also a good harbor for refuge in storms or from drifting ice. The mouth of the river is, however, so nearly closed by the bars projecting from opposite sides that a vessel endeavoring to avoid one is in danger of being stranded upon the other. Hence sailing-vessels rarely attempt to leave or enter at night. In 1883, the steamer *Sue* in going out, by a mistake of one minute in the time of running, ran upon the bar at Cob Point. The light at Blakistone's Island is nearly 5 miles distant from this bar and affords no guide to this location.

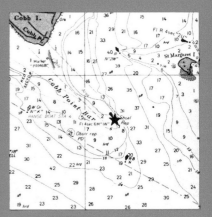

Thus the Board's rationale in 1885. An appropriation of $15,000 was requested, but it took five years to get the money and build the light.

It was a square wooden structure standing on five iron screwpiles. Its fixed white light of the fourth order was shown for the first time on the night of December 25, 1889. The cost had gone to $25,000, but the investment was worth it: even though it is now called Wicomico River Entrance Light, the foundation still serves a small automatic light. The house itself was dismantled in 1940.

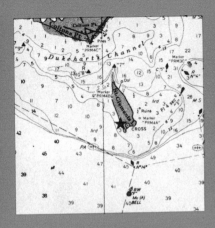

Blakistone Island

Leonard Calvert (Lord Baltimore's brother) and 220 emigrants landed on the Potomac's Blakistone Island (then and now called St. Clements) on March 25, 1634, after crossing the Atlantic in their tiny ships, the *Ark* and the *Dove*, and "among the trees and flowers, celebrated the first Mass in Maryland."

Stephen Pleasonton wrote to a member of Congress in the 1830s that "as we have a Light-House on Piney Point and two Light-Vessels in the River, the one at Upper and the other at Lower Cedar Point within a few miles of which Blackstones Island lies, I cannot perceive any good reason for putting a light there." Nevertheless, a lighthouse was built on the island by John Donohoo in 1851, at a cost of $4,880. The light tower was placed on top of a symmetrical brick two-story house. A porch covered the full width of the house, and steps led down to the water's edge, which was protected by a cobblestone retaining wall. But like so many lighthouses on the erosion-prone Chesapeake shoreline, it was built too close to the beach. (The island was estimated at 400 acres in 1634; now it measures only 22 acres, and the land continues to disappear). The Lighthouse Board noted a decade later that some way of protecting the light was needed, and bulkheading was provided.

In May, 1864, Confederate raiders put the light out of commission, but the damage was quickly repaired and the light was restored several days later. The lighthouse was decommissioned in 1932. On July 16, 1956, it burned to the ground; the cause of the fire was never ascertained. A huge cross was erected on St. Clements Island to commemorate the landing of Leonard Calvert. Nothing remains of the light but some brick rubble.

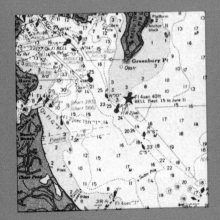

Greenbury Point Shoal

Greenbury Point, at the mouth of the Severn River near Annapolis, has had two lighthouses. The first light was located on the point, now the site of a naval radio station. On it in 1649 was located the first white settlement in Anne Arundel County.

On a few acres purchased for $367 a lighthouse was erected in 1849, a small, beautifully proportioned house 21 feet high with an eight-sided tower on top of the roof. It was outfitted with nine lamps using 14-inch reflectors; they were replaced with a more efficient steamer's lens in 1855. The house was flanked by two large trees and surrounded by a sturdy fence. A small whale-shaped weathervane was attached to the top of the lantern.

In 1878 the Lighthouse Board complained that the land around Greenbury Point was washing away and that eventually the lighthouse would be in danger. The light was of little use where it was and was so small that it could hardly be distinguished from the lights of the Naval Academy, and of the Annapolis harbor. As present-day yachtsmen can testify, that problem still remains. The following year the Board asked for monies to build another light on the shoal 1,000 yards from the old lighthouse. For ten years the request was repeated. Finally, in 1891, a screwpile lighthouse was built for nearly $25,000, and the old light was discontinued. The Board requested that "the old lighthouse be retained as a day-mark," and it was, for several decades, until the building collapsed. The new Greenbury Point Shoal light superstructure was dismantled, and the light was automated in 1934. It still flashes every four seconds to help guide mariners into Annapolis harbor.

Bodkin Island

"An island commonly called Bodkin" was the site of the first lighthouse in Maryland. Funds were appropriated in 1819, after William B. Barney, naval officer of the Port of Baltimore, complained that "the want of a lighthouse on this scite becomes very evident to one who is a few days in its vicinity. The Bar was never without one or more vessels aground while I was in that neighbourhood."

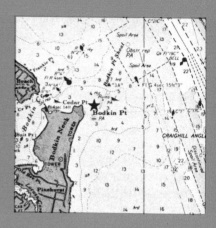

Barney entered into a contract with Thomas Evans and William Coppuck in June, 1821, but things did not go smoothly. Evans, Barney complained, "and a certain Coppuck, contracted with one in June 1821 to build a Light house at the Bodkin Island, when I very soon found what sort of characters I had to deal with; for I had to compel them to pull down fifteen feet of the work having been so far erected, not in accordance with the terms of the contract."

The lighthouse, like most others subsequently built in the upper Chesapeake, was a round stone tower, 35 feet high, 18 feet in diameter at the bottom, and 9 feet in diameter near the top, with a 34- by 20-foot stone dwelling attached to the tower. The building was finished on July 8, 1822, and the light helped guide vessels into the Patapsco River until January 10, 1856, when the newly built Sevenfoot Knoll lighthouse, a mile and a half northeast, took over its function. The Bodkin light stood forlorn—shorn of its lantern—for decades. The tower was taken down in the early 1920s; Bodkin Island itself has disappeared.

Brewerton Channel Range

The lights marking this channel in the Patapsco River were exhibited for the first time on the evening of November 1, 1868. They stand a mile and an eighth apart, one near Hawkins Point, the other on Leading Point, bearing northwest and southeast from each other, both exactly in range with the axis of Brewerton Channel. Hawkins Point light, the front one, stands in six feet of water on a screwpile foundation. Its frame superstructure originally supported two lights, one above the other, at heights of 28 and 70 feet, respectively, above ordinary tides. The rear light, Leading Point, is built on a bluff. When built, it was a brick dwelling surmounted by a lantern and showed one light at an elevation of 40 feet above ground and 70 feet above mean low water. When a vessel is on a true course coming up or going down the channel, the three lights could be seen in line, one above the other; whenever this course was departed from, however slightly, to port or starboard, there was an observable change in the position of the lights.

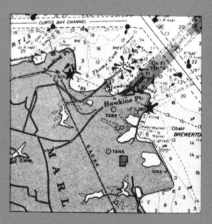

Both lights, only seven miles from downtown Baltimore, still serve today as range lights, flashing a green light of 50,000 candlepower 24 hours a day. However, the front light is now only a small beacon on the old pile foundation. The rear light was converted to a skeleton tower in 1924 and the lighthouse torn down.

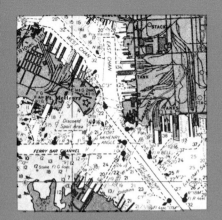

Lazaretto Point

"Lazaretto" means pesthouse or fever hospital in Italian, and in the early 1800s a hospital for contagious diseases, especially smallpox, was located on this point opposite Fort McHenry in the Baltimore inner harbor. The lighthouse was built by John Donohoo in 1831 for $2,100. It was a 34-foot-high whitewashed brick tower with a detached keeper's dwelling, and some say that it inspired Edgar Allen Poe's unfinished short story "The Lighthouse."

The lighthouse was offered by the Lighthouse Board in 1852 as proof that the new Fresnel lenses, with their greater efficiency, were much cheaper to operate than the old system, which at Lazaretto employed eleven lamps with spherical reflectors and consumed close to 450 gallons of oil annually. The Board demonstrated that the smallest Fresnel lens used with only one lamp would increase the brilliance of the Lazaretto light considerably, at a saving of 900 percent!

In 1863 a vein of iron ore was discovered running through the lighthouse property, and for the next five years a local contractor mined 3,662 tons of ore from the site. The Lighthouse Board was paid $5,662.50 for this privilege. When the excavations actually came into the keeper's garden close to the light tower, the Board called a halt and made the mining company fill in the holes. Many iron foundries moved into the surrounding area during the 1860s, and in 1870 the characteristic of the light was changed from red to white because it was so close to the smelting furnaces that the red light was hard to distinguish.

In 1885 it was proposed that the light tower be moved nearer the water to get it away from the newly constructed factories and warehouses in this booming industrial area, but moving it proved too costly, and instead a 70-foot mast was erected next to the lighthouse and a lantern suspended from its top. The mast was taken down in 1888 and the light in the tower reactivated. For the next several decades steamship companies continued to complain about the uselessness of the light, but nothing was done about it.

In 1916 Lazaretto lighthouse became the first in Maryland and Virginia to be electrified because of its location and proximity to the generating station. In 1926 the light was discontinued and the tower torn down. A new steel tower was built, 39 feet high, with a light of increased candlepower, located some 100 yards nearer the water. The lighthouse service depot, which was located on the Lazaretto property, was kept until 1958, when it too was closed down and the land sold to commercial interests.

North Point Range

The first "North Point Ranges," as they were then called, were built in 1822 and were used until 1886. New lights were then built, in a slightly different location, and called "Cut-Off Front and Rear Lights." (The purpose of range lights is outlined in the description of Brewerton Channel lights.)

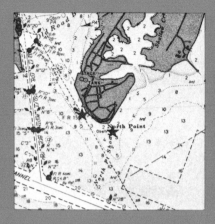

Benjamin H. Latrobe, the famous architect, was consulted about the design of these lighthouses a few months before he died in 1820. He submitted plans and sections and urged the erection of stone or brick towers rather than wood, pointing out the fire hazards of the latter. Both towers were built in 1822, although they were not lighted until January of the following year.

The Eastern North Point light was the first to be completed. It was located 200 yards from shore, in three feet of water "at common tide," and was 27 feet high and built of stone. A 6-foot-wide footbridge led to shore, where the keeper's house was located. The house was a one-story 34- by 20-foot stone house with an attached kitchen 14 by 12 feet. The cost for the light and the house was $6,637, and an additional $850 was paid to Winslow Lewis for installing the nine patent lamps. The naval officer at Baltimore, William P. Barney, who was responsible for supervising the construction, had contracted with Thomas Evans and William Coppuck, the men who built the Bodkin light across the river and whose performance there had left a lot to be desired. The Eastern light was more than a year late in being completed. As a matter of fact, the conduct of Evans and Coppuck during the construction was "so infamous," said Barney, "that it became necessary to employ a person at one dollar per day, to overlook them during the time they were at work."

The Western North Point lighthouse was built later that same year. The advertisement for the contract stated: "let it be understood that the former contractors having essentially failed to give satisfaction, no proposals from them will be accepted," and the contract was let to Messrs. Freize and Ring. The Western tower, built for $7,300, plus Mr. Lewis' fee, was located 700 yards to the west of the Eastern light, in five feet of water, 100 yards from shore. It was 35 feet high. One keeper tended both lights, which served as range lights for the ship's channel. The Western light also had nine lamps and through filters showed a "blood-red" light.

The first keeper was a member of the Maryland House of Delegates, and he asked for, and was granted, a leave of absence so that he could attend the session in Annapolis during the early winter of 1823. When the new lights at this location were built in 1886, the stone foundation for the Western light was used as a base for one of the new towers.

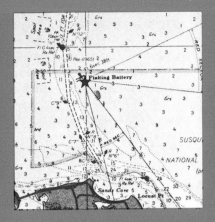

Fishing Battery

This lighthouse was located in the northern Chesapeake, four miles from Havre de Grace, on the east side of the channel leading from the Bay to the mouth of the Susquehanna River. On early maps the tiny, three-acre island (which has now disappeared) is variously called Shad Battery, Edmonson Island, and, occasionally, Donohoo's Battery, after John Donohoo, one of its owners. "I unhesitatingly say, that for vessels running at night, I consider it necessary to have a light here," wrote an officer of the Lighthouse Board in 1852, and on August 10, the Board purchased a 45- by 45-foot plot from Donohoo and his partner, Robert Gale, for $10. Gale and Donohoo had no business selling the plot, for the land did not belong to them: ten years earlier, while they were embroiled in some legal proceedings, the island had been sold by the sheriff to one Otho Scott for $300. Scott promptly offered to sell the plot to the government for $600. The attorney general later approved the Scott sale; there is no record whether Donohoo and Gale returned the $10 to the Treasury.

The lighthouse was built in 1853. It showed a fixed white light through a sixth-order Fresnel lens. The lantern, 32 feet above the ground, was built on top of the keeper's house. In 1921 the lighthouse was demolished after a steel tower with an automated light burning acetylene gas was erected at a cost of $1,545. From 1880 to 1891 the rest of the island was leased to the Bureau of Fisheries, which used it for fish culture studies. Some years later the Bureau purchased the island for $15,000. In 1942 the property was transferred to the Department of the Interior and became part of the Susquehanna Wildlife Refuge.

Love Point

Love Point finally got its lighthouse on August 15, 1872, but it took some doing. In 1837 Captain Alexander Claxton, an advisor to the lighthouse service, reported to his superiors:

> A lighthouse at Love Point (north end of Kent Island) is uncalled for by the exigencies of commerce. It would be totally useless for vessels passing up or down the bay, and it is not *necessary* for the limited number of craft trading in the Chester river . . . The channel between Love Point and Swan Island is a mile and a half wide, and with the Bodkin light to shape a course, the entrance is safe and certain; no loss has been sustained, no inconvenience felt. Believing this to be one of the numerous classes of appropriation obtained more with the view to local interest and patronage than to public benefit, I consequently report *adversely* to the contemplated erection.

But local pressure kept up, and in 1857 a small appropriation was made. It was quite insufficient to build a screwpile light, however.

Years later, in 1870, an additional $15,000 was added to the fund, construction began, and the lighthouse was completed in 1872. In its first winter the light was discontinued for several weeks after the keepers had been taken off. Ice had severed several of the pilings, and the recent experience of other lighthouses under such circumstances made the lighthouse service determined not to take any chances. The light was repaired in short order, and $15,000 worth of stone was deposited around the structure to act as an icebreaker. The lighthouse was automated in 1953; the building was torn down in 1964, but the old pile foundation still serves as the base for a small flashing light and a fog bell.

Choptank River

For one year before this lighthouse was built, a lightship was stationed near the southeastern extremity of the shoal making out from Benoni's Point. This 41-ton schooner-rigged vessel, with white masts and lead-colored hull, bore the legend "Choptank River" in large white letters on each side. Partly because of the lack of experience on the part of the contractor (who was the lowest bidder), the screwpile lighthouse was not finished until 1871, several months after the target date. It was founded on six wooden piles encased in cast-iron sleeves. Four fender piles, constructed in a similar manner, served as icebreakers.

Choptank River light in its first ten years had a sixth-order Fresnel lens; in 1881 a new fifth-order lens was installed. By 1921 the lighthouse had become quite dilapidated, and it was decided to tear it down and replace it with the Cherrystone Bar light (located nearly 100 miles south—see the description of Cherrystone Bar) which had recently been superseded by an automatic beacon. The surplus lighthouse was towed up the Bay to the Choptank on a barge, and the lamps were lit again on June 2, 1921. So it became the only known lighthouse "transplant." Its superstructure served until 1964, when it was torn down for good. The foundation still supports a small modern beacon light, and a fog bell clangs continuously during the winter months.

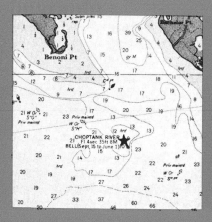

Clay Island

In 1673 the first accurate map of Virginia and Maryland was printed in London by Augustine Herman (or Hermann), a Bohemian by birth who in 1666 became the first foreign-born citizen of the Province of Maryland, and so could own property. Herman's map, on which he had worked for ten years, was paid for in land, 15,000 acres altogether, all of it located at the head of the Chesapeake, near the Bohemia River. (He was, incidentally, the first person to propose, in 1661, the digging of the Chesapeake and Delaware Canal.) In Daniel Defoe's novel *Moll Flanders* Moll sails to a place called Phillips Point, which is shown on Herman's map. It is the present Clay Island, a spit of land between the Nanticoke River and Fishing Bay on the Eastern Shore of Maryland.

A site for a lighthouse was purchased in 1828 for $600, and four years later the lighthouse, a small house with a tower on its roof, was completed. Fifty years later the site was reported to be washing away, and an inspector for the Lighthouse Board wrote that although the station had been in bad condition for some time past it had not been repaired because a new lighthouse at Sharkfin Shoal was to replace it. The Sharkfin Shoal light was finished in 1892, and the Clay Island light was discontinued. The house collapsed in 1894, and no trace of it remains.

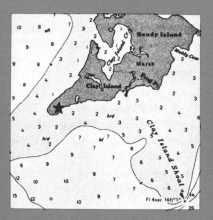

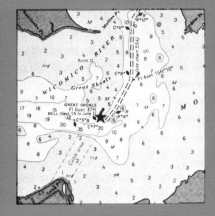

Great Shoals

The record for the fastest construction of any lighthouse on the Bay is probably held by Great Shoals. The Lighthouse Board annual report for 1885 describes the unusually efficient work.

On July 17, 1884, the tender *Jessamine*, with a working party on board and scows in tow carrying the metal-work, reached the site. The trestles were at once placed in position and the working platform constructed. The driving of the piles was commenced on the 19th and finished on the 21st. The iron foundation was all in place on the 22nd. The frame was erected on the 26th, and by the 28th it was sheathed and weather-boarded. By the 31st the tin roof had been completed, the main floors laid, the lantern and lower gallery railing and decking put up, some of the inside work completed, and the outside of the house painted. On August 5th, the platform was removed, and on the 9th all the work except the painting was completed. Two men were left to finish the inside painting and await the arrival of the keepers. The light was shown from the new house on August 15th, 1884, in accordance with the published *Notice to Mariners*.

The lighthouse was a square pile structure which exhibited a fixed white light through a fifth-order lens. It was located one mile from shore, near Wingate Point, at the entrance to the Wicomico River on the Eastern Shore of Maryland. The superstructure was demolished in 1966 and an automatic light installed on its foundation.

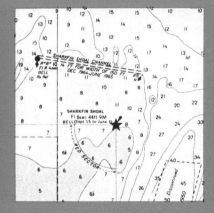

Sharkfin Shoal

Sharkfin Shoal lighthouse was established on August 1, 1892, to take the place of Clay Island light, two miles to the northeast, whose site was being rapidly washed away. The Board spent $25,000 to construct a screwpile light with a fourth-order lens.

In 1964 the light was converted to automatic operation, and a light is now shown from a steel tower built on the skeleton of the old foundation. Conversion of the old screwpile lighthouses was usually handled in the following way. The wooden house was removed, and, where necessary, the old beams of the foundation were replaced by new steel I beams. A reinforced concrete platform was then poured, and a small concrete-block battery house, about 8 feet square and 10 feet high, was built in the center. A skeleton steel tower was erected on top of the battery house to bring the new light up to the height of the old lantern.

By 1964 all the screwpile lights on the Bay had been converted to automatic operation except for the one at Thomas Point Shoal, which is still manned today. The maintenance of the wooden superstructures is simply too costly, and with improved storage batteries to power the lights, even the most isolated ones can be depended on to perform reliably at all times and seasons.

Holland Island Bar

At Holland Island Bar, a screwpile lighthouse built in 1889 and dismantled and automated in 1960, one of the most bizarre accidents ever to befall a lighthouse took place. The lighthouse was located in the middle of the Bay, near Smith Island, a few miles north of the wreck of an old ship frequently used for target practice by the Navy and Air Force. At 9:30 P.M. on February 18, 1957, three fighter bombers from the Naval Air Station at Atlantic City, New Jersey, mistaking their target, attacked the lighthouse with rockets. After one pilot dropped flares, the other planes fired seven rockets, three of which hit the target. Although the rockets did not carry live explosives, they managed to inflict severe damage on the building. Two of the four keepers aboard at the time were slightly injured by falling debris, and several pilings were severed. The keepers immediately notified Coast Guard headquarters by radio, and the Navy across the Bay at Patuxent Naval Air Station sent a helicopter with a doctor aboard, who was lowered in a sling to give first aid to the two victims.

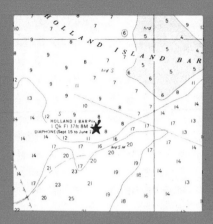

It took several hours to discover where the planes had come from, and the Coast Guard, taking no chances on the possibility of an enemy attack, ordered the men to evacuate the lighthouse. But the light was kept burning through the night, despite the Navy's efforts to snuff it out, and the following day the keepers returned and proceeded with the job of cleaning and repairing the only lighthouse ever to be used for target practice.

Fog Point

Little is known about Fog Point light, which was located on the northwestern tip of Smith Island, an isolated community of oystermen and fishermen in the middle of the Chesapeake. It was established in 1827 on a few acres purchased for $200 from Richard and Euphemia Evans, both illiterate, who signed the deed with a large X. The lighthouse was built for $3,500 by John Donohoo. It was originally outfitted with ten lamps with 16-inch reflectors. A fifth-order Fresnel lens was installed in 1855 after the Lighthouse Board noted that "the lighthouse at Fog Point, being at present fitted with lanterns of an old and exceedingly defective character, the interests of commerce demand that steps be taken to remedy the evil."

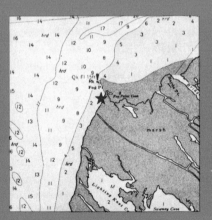

The light became increasingly useless as shoaling occurred and ships were forced out of its useful range. When Solomons Lump lighthouse, a mile and a half to the northeast, was completed in September, 1875, Fog Point light was discontinued and abandoned, and all traces of it have disappeared.

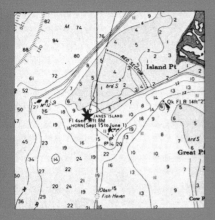

Janes Island

Janes Island, or James Island, as it is called now, is a small marshy island on the north side of the entrance to the Little Annemessex River near Crisfield, Maryland. A lightship was anchored here in 1853, but by 1866 the ship was leaking badly and was replaced by a relief vessel. When a Baltimore shipyard estimated the cost of repairs at $8,000 it was decided to auction her off. She sold for $518.55.

A screwpile light was built the following year, in 1867. It was destroyed by ice, a common fate of many of these lights, on January 20, 1879. Another lighthouse was built shortly afterwards, and it lasted a bit longer, but it too was eventually sheared off its foundation by ice in 1935; the superstructure floated for three days in Tangier Sound and finally sank. There was no keeper at the light, for it had been automated for several years. The following year a skeleton tower was built on a new cylindrical caisson base, and its light, 37 feet above the water, still flashes today.

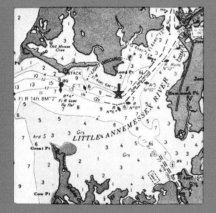

Somers Cove

The Lighthouse Board, in a reply to an inquiry from an interested history buff, wrote that "the files of this office contain no records of any particular historic interest in connection with this light," apart from the fact that it was a screwpile structure of the "least expensive class." The tiny lighthouse was built in 1867 for less than $10,000, and the lantern housed the smallest (sixth-order) Fresnel lens. It was located on the north side of the Little Annemessex River, at the entrance to the Crisfield, Maryland, harbor.

Compressed acetylene gas was used when the light was automated and the house demolished in the 1930s; the foundation was kept, a flashing white light installed, and it was renamed Little Annemessex River Light No. 7. The name Somers Cove now refers to the protected inner harbor of Crisfield, whose Chamber of Commerce is fond of calling it "the seafood capital of the world."

Tangier Sound

"There has been of late a great increase of the commerce of this section," said a report in 1887, and at a cost of $25,000 a square screw-pile light was built in 1890 at the western side of the entrance to Tangier Sound. In 1905 the most exciting event in its history took place. The Baltimore *News-American* headlines read, "Lighthouse in Peril: Sunken Schooner Hurled Against Structure With Great Force. Peculiar Condition." The story read as follows:

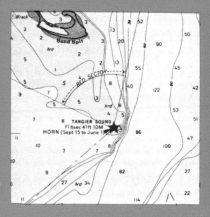

The first report of the anticipated damage to lighthouses by the breaking up of the ice reached the city yesterday. The hull of the wrecked and sunken pungy schooner *Mary L. Colburn* collided with the lighthouse at Tangier Sound, Virginia, doing much damage and causing danger to the inmates. The vessel had been lost on the bar marked by the lighthouse, and her collision with the light was very peculiar. When, on February 13, the ice broke, the wrecked schooner was lifted up bodily and hurled against the staunch lighthouse. The crash was terrific, and the ship, as though tossed by some giant hand, fetched up broadside to the lighthouse on the southeastern face of the station. The impact was terrific, and both masts were plucked out of the vessel to the deck. The top of one of the smoke stacks of the lighthouse was carried away by fouling with some of the gear of the schooner as it went by the board. One corner of the roof over the bell suffered a like fate, the head of three posts around the dome of the light were also wrecked and general damage done. The situation at the light is now perilous in the extreme, and the lighthouse tender *Maple* has been sent to relieve the men and to pull away the battered hull of the schooner. Mr. John T. Jarvis, keeper of the light, in a letter to the office of the Fifth Lighthouse District, declares that the hull of the vessel is a serious menace to the lighthouse and that it may be difficult to keep the light burning. Should there come a SE by S or SW wind the sea would use the vessel's hull as a battering ram to batter down the SE or SW piling that protects and on which stands the lighthouse. The sea now raises and throws the wreck against the piling with terrific force, and the occupants have hourly expected the station to yield to the pounding. The wind had changed from the southward when Mr. Jarvis wrote, and the situation was being relieved, as nothing but clear ice was in sight. The experience is the most peculiar in the history of the Fifth Lighthouse District.

A much more costly tragedy occurred in 1914, when the keeper then, E. L. Thomas, was cited for his "brave but futile attempt" to save the life of the assistant keeper, William A. Crockett, who had fallen overboard.

The lighthouse was automated and the superstructure torn down in 1961. A steel tower, the same height as the original lantern, was built on top of the screwpile foundation. The battery-operated light on top of the tower still flashes every six seconds.

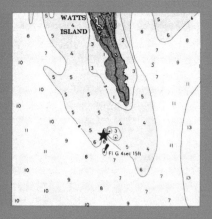

Watts Island

"Neglected and filthy," wrote the captain of the lighthouse service supply boat when he visited Watts Island lighthouse in 1840. A 48-foot light tower and a 34- by 20-foot keeper's house had been built by John Donohoo in 1833 at a cost of $4,755. The island on which it was built was called Little Watts until 1867, when it began to be referred to as Watts Island, which was really the name of a 200-acre island 700 yards to the north.

Little Watts was a seven-acre island in 1832; by 1923, when the light was automated, it had been reduced to three. The house and the island, except for a circle 30 feet in diameter where the tower stood, was sold for $726 to a Baltimore insurance company executive.

Both the tower and the house were destroyed during a severe winter storm in 1944. In subsequent years the erosion of the island continued and it has now disappeared from the map. Only a lighted buoy marks the place 16 miles south of Crisfield, at the confluence of Tangier and Pocomoke Sounds, where Watts Island lighthouse stood for 111 years.

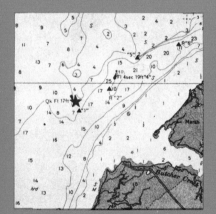

Pungoteague River

Pungoteague River is really a creek, and so it is called now. It is located on the lower Eastern Shore of Virginia between Hacks Neck and Dahl Swamp. The lighthouse which once stood here was the first screwpile light built on the Chesapeake. It lasted 459 days, the shortest recorded existence of any lighthouse on the Chesapeake and possibly anywhere.

Most of the foundation was prefabricated in Philadelphia. On April 23, 1854, the construction crew set out for the lower Bay. It was estimated that only six weeks would be required for the erection, but lengthy calms during the voyage from Baltimore, coupled with the crew's inexperience and the difficulty encountered in sinking the pile foundation drew out the process to almost six months.

The lighthouse was finished and commissioned on November 1, 1854; it was overturned by a large mass of floating ice on February 2, 1856. Nobody was lost or injured; the location near shore made the escape and rescue of the keeper relatively easy.

Title was sought and obtained for a new lighthouse and $5,000 was appropriated, but the maritime traffic did not really justify building another one, and the monies reverted to the Treasury. A privately maintained lighted beacon was located at the site for some time, and in 1908 the lighthouse service installed a flashing light on a permanent base, which cost nearly as much as the original lighthouse—$8,000.

Cherrystone Bar

The hexagonal fourth-order screwpile lighthouse which stood near the town of Cape Charles on the Eastern Shore of Virginia was built in 1859 for almost $10,000. The Lighthouse Board had pleaded for its construction for years because "next to Pungoteague River, which is about 25 miles to the northward, Cherrystone is the best harbor on the southeastern part of the Chesapeake Bay."

The lighthouse was discontinued in 1919, when an automatic acetylene-fed lantern was installed on a steel skeleton tower anchored on a caisson. In October, 1920, the lighthouse was removed from its base, loaded on a barge, and brought to the docks at Cape Charles, where it stayed during the winter months. On April 20, 1921, the six-sided building was loaded on a barge again and towed up the Bay to the Choptank River light, an 11-hour trip. Choptank light was now fifty years old and had not aged gracefully. Cherrystone light was to replace it. New foundation pilings were screwed into place, on June 1 the house was lowered over them and attached to the base, and the lens and lantern were installed. The next day Cherrystone Bar was lighted again and was given a new name, Choptank River. In 1964 it was dismantled by the Coast Guard, this time forever.

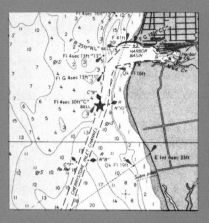

Old Plantation Flats

Old Plantation Flats is a mile-long sandbar several miles southwest of Cape Charles City. Constructed at a cost of almost $25,000, it was lighted on September 5, 1886. It was a square white screwpile lighthouse with green blinds. In the middle of the 1917-1918 winter, the light was badly damaged by ice, the nemesis of screwpile lights. Two of the five wrought-iron piles were broken, and severe damage was done to other parts of the building. It was repaired the following summer, and 4,600 tons of stone were deposited around the light to keep it from happening again. It worked (the foundation stands today), but the cost was one and a half times that of the original construction—$37,140.30. Ice was the culprit more than once: "In January [1893] the shock of the moving ice overturned and broke the lens. The light was discontinued, but only temporarily. A spare fifth-order lens was substituted in February, which was as soon as the tender could get to the station. No damage to the structure was done by the ice." In 1962, after the house was demolished under the Coast Guard's modernization program, a modern beacon was erected on its foundation.

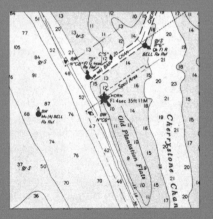

Note: The sources for this book include personal interviews with retired keepers; newspaper clippings; the *Light List,* issued annually by the U.S. Coast Guard; the *Coast Pilot,* issued periodically by the Department of Commerce; the collections of the Pratt Library in Baltimore and The Mariners Museum in Newport News; and the extensive group of lighthouse service records in the National Archives. Almost all the records consulted in the course of my research are contained in National Archives Record Group 26, an enormous collection of correspondence, journals, reports, ledgers, and logbooks pertaining to aids to navigation in general and to lighthouses in particular. Direct quotations in the text not otherwise identified are taken from this source. The newspaper and magazine clipping files maintained on individual lighthouses by the National Archives yielded a substantial amount of information. In many cases, old photographs kept by its Audio-Visual Department allowed me to describe lighthouses that no longer exist. The collection is by no means complete. During a disastrous fire in 1921 many of the records were destroyed, but the material pertaining to the fifth district, which encompasses the Chesapeake Bay and its tributaries, seems to have escaped relatively unharmed. An excellent inventory of these records was prepared by National Archives historians under Dr. Forrest R. Holdcamper in 1963 and 1964 and is available to researchers. My own search was facilitated by the able assistance of William Sherman.

Adamson, H. C. *Keepers of the Lights.* New York: Greenberg, 1955.

Brewington, M. V. *Chesapeake Bay, A Pictorial Maritime History.* Cambridge, Md.: Cornell Maritime Press, 1953.

Burgess, Robert H. *Chesapeake Circle.* Cambridge, Md.: Cornell Maritime Press, 1965.

Burgess, Robert H. *This Was Chesapeake Bay.* Cambridge, Md.: Cornell Maritime Press, n.d.

Carse, Robert. *Keepers of the Lights.* New York: Scribner's, 1969.

Conklin, Irving. *Guideposts of the Sea.* New York: Macmillan, 1939.

de Gast, Evelyn Chisolm. *The Lighthouses of the Maine Coast.* Camden, Me.: International Marine, forthcoming.

de Gast, Robert. *The Oystermen of the Chesapeake.* Camden, Me.: International Marine, 1970.

Heap, D.P. *Ancient and Modern Lighthouses.* Boston: Ticknor & Co., 1889.

Holland, F. Ross, Jr. *America's Lighthouses.* Brattleboro, Vt.: Stephen Greene Press, 1972.

Johnson, Arnold B. *The Modern Lighthouse Service.* Washington, D.C.: U.S. Government Printing Office, 1889.

Lewis, Steven H. *Historic Structures Report: Jones Point Lighthouse.* Unpublished report in possession of the Division of History Studies, National Park Service.

Middleton, Arthur Pierce. *Tobacco Coast, A Maritime History of Chesapeake Bay in the Colonial Era.* Newport News, Va.: The Mariners Museum, 1953.

Putnam, George R. *Lighthouses and Lightships of the United States.* Boston: Houghton Mifflin, 1917.

Putnam, George R. *Sentinel of the Coasts: The Log of a Lighthouse Engineer.* New York: W. W. Norton, 1937.

Report of the Officers Constituting the Lighthouse Board. Washington, D.C.: 32nd Cong., 1st sess., Exec. Doc. 28, 1852.

Snow, Edward Rowe. *Famous Lighthouses of America.* New York: Dodd, Mead, 1955.

Stevenson, D. Alan. *The World's Lighthouses Before 1820.* London: Oxford University Press, 1959.

U.S. Coast Guard. *Historically Famous Lighthouses.* Washington, D.C.: U.S. Government Printing Office, 1957.

U.S. Commissioner of Lighthouses. *Annual Reports, 1911-1932.* Washington, D.C.: U.S. Government Printing Office, 1911-32.

U.S. Lighthouse Board. *Annual Reports, 1852-1910.* Washington, D.C.: U.S. Government Printing Office, 1852-1910.

U.S. Lighthouse Board. *Documents Relating to Lighthouses, 1789-1871.* Washington, D.C.: U.S. Government Printing Office, 1871.

U.S. Lighthouse Board. *Instructions and Directions To Guide Light-House Keepers and Others Belonging to the Light-House Establishment.* Washington, D.C.: U.S. Government Printing Office, 1870.

U.S. Lighthouse Board. *Instructions to Light-Keepers.* Washington, D.C.: U.S. Government Printing Office, 1881.

Weiss, George. *The Lighthouse Service, Its History, Activities, and Organization.* Baltimore: Johns Hopkins Press, 1926.

Wilstach, Paul. *Tidewater Maryland.* Indianapolis, Ind.: Bobbs-Merrill, 1931.

Alphabetical List

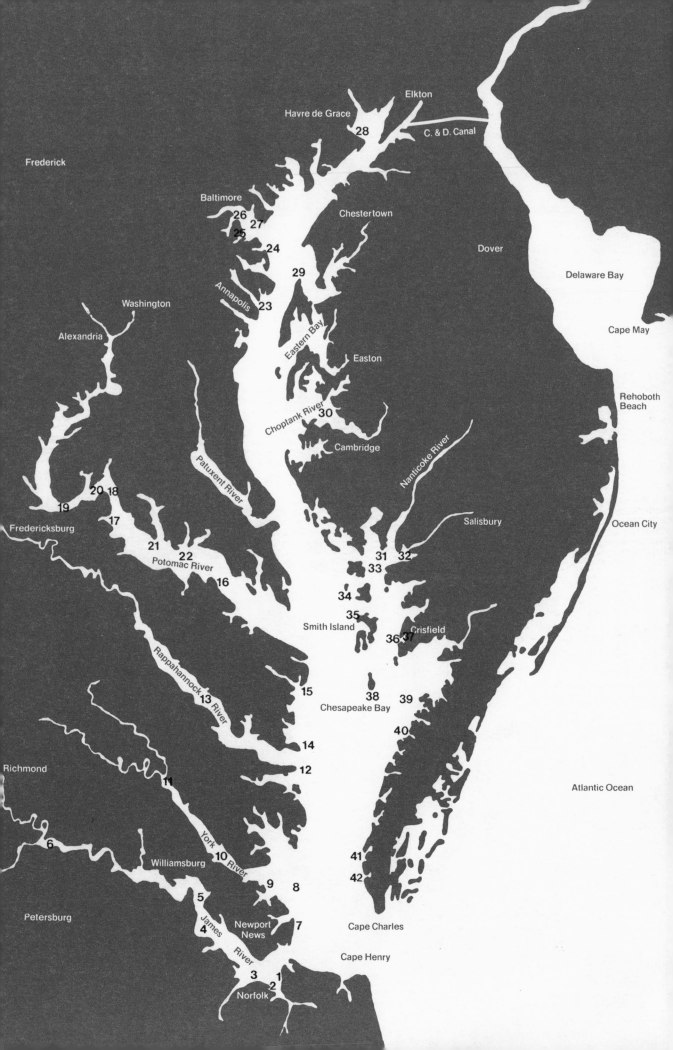